4/01

5/01 1 7/03 2

North American Art Since 1900

first edition

C.M.E.P. Turner

Facts On File, Inc.

INTERNATIONAL ENCYCLOPEDIA OF ART
NORTH AMERICAN ART SINCE 1900

Text copyright © 1996 C.M.E.P. Turner
Copyright © 1996 Cynthia Parzych Publishing, Inc.
Design, maps, timeline design copyright © 1996 Cynthia Parzych Publishing, Inc.

Cataloging-in-Publication Data available on request from
Facts On File, Inc.

Facts on File books are available at special discounts when purchased in bulk quantities
for businesses, associations, institutions or sales promotions. Please call our
Special Sales Department in New York at 212/967-8800 or 800/322-8755.

This is a Mirabel Book produced by:
Cynthia Parzych Publishing, Inc.
648 Broadway
New York, NY 10012

For J.A.A.T. and in memory of Buck, Dotty, Gus, and Tony.

Edited by: Frances Helby
Designed by: Dorchester Typesetting Group Ltd.
Printed and bound in Spain by: International Graphic Service

Front cover: *Three Flags* by Jasper Johns was painted
in encaustic on canvas in 1958.

10 9 8 7 6 5 4 3 2 1

Contents

Introduction

The beginning of the twentieth century was a time of revolutionary change in science, politics and the arts in many parts of the world. People who lived then felt these changes were overturning the certainty of their lives. Ways of living and thinking, taken for granted in the nineteenth century, began to be challenged.

In the world of science the discovery of X-rays in 1895 and radium in 1898 proved that matter was neither solid nor stable. Albert Einstein's (1879–1955) theory of relativity, published in 1905, proved that matter changes dimension depending on its speed through time. In 1900, in *The Interpretation of Dreams*, Sigmund Freud (1856–1939) dra-matically changed the way people looked at human behavior.

In the United States, the strength of American Indians to survive under great stress and to keep alive the culture that the white man had tried to destroy, the energy of immigrants arriving in a new country to assimilate American life and make it work for themselves, the movement for the right of women to vote and the push for progressive labor and social reform all became irresistable forces in the early 1900s. This great social and political energy led to enormous changes throughout the century.

In the arts, traditional American Indian arts and crafts began to be viewed, at the turn of the

Timeline

This timeline lists some of the important events, both his-torical (listed above the time bar) and art historical (below) that have been mentioned in this book. While every event cannot be mentioned it is hoped that this diagram will help the reader to understand at a glance how these events relate in time.

early 1900s: American Indian tribal life is finally destroyed and Indians are forced to live on reservations.

1901: Teddy Roosevelt becomes president and progressive legislation is passed. Women's suffrage movement and trade unions grow. New technology creates work opportunities for women. Immigrants stream into the U.S.

1900–09 A.D.

early 1900s: American Indian arts and crafts survive on reservations. Photography begins to appear in newspapers and magazines. Social photographers like Jacob Riis expose poor living and working conditions in U.S. cities.

1906: Gallery 291 opens.

1908: The Ash Can School holds its first exhibition in New York.

by 1910: Most of the U.S. population in cities is foreign-born.

1913: Woodrow Wilson becomes president.

1914: World War I begins.

1917: The U.S. enters World War I.

1918: World War I ends.

1910–19 A.D.

1910–20: Self-Taught Painters work near San Ildefonso, New Mexico.

1910: Arthur G. Dove paints the first American abstract painting.

1913: The Armory Show opens on February 17 and marks the beginning of collecting of American art by many American collectors.

After 1913: Synchromists, Precisionists and other artists experiment with European modern painting styles in the U.S.

1920s: Rise of black nationalism in U.S.

1925: Scottish inventor John Logie Baird transmits the first recognizable human features using television.

1928: Station WGY in Schenectady, New York runs the first scheduled television broadcast.

1929: Herbert Hoover becomes president. The stock market crashes in October marking the start of the U.S. Depression that lasts ten years.

1920–29 A.D.

1920–40: American Scene Painters work. The Harlem Renaissance flourishes in the 20s.

1920: The Société Anonyme and the Group of Seven are formed.

1924: The Whitney Studio Club holds the first Folk Art exhibit in America.

1928: The Federal Indian Office encourages Indians to produce arts and crafts for cash.

century, as "fine art" for the first time as Indian painters began to use the methods and materials of white artists. By 1900 photography had changed, in the approximate sixty years since its invention, from a scientific experiment to a hobby accessible to the man *and* woman on the street. Photography was maturing into one of the fine arts in the hands of Alfred Stieglitz and the Photo-Secessionists by about 1905.

American painters and sculptors in the first decade of the twentieth century began to reject the European models for making art and to search for a uniquely American means of expressing themselves through art. Robert Henri and the Eight used American subject matter and an exciting, unorthodox style that shocked people. They took the first steps to try to develop an American way of making art. At about the same time Alfred Stieglitz, his partner Edward Steichen and the group of artists that

gathered round gallery 261 from 1906 to 1917, introduced modern, avant-garde ways of making art to New York based on European contemporary art, but only to a very select audience. Truly revolutionary, however, was The Armory Show of 1913 that opened in New York and traveled to other American cities, causing tremendous public excitement all over the country. This is considered the most important event in modern American art, because it introduced modern art to the general American public. After this exhibition American art began to change. Perhaps just as important, many American art collectors began to buy contemporary American art for the first time.

The change in art after the Armory Show of 1913 came about slowly. While there were always American artists that worked independently and innovatively like the painter Stuart Davis and the sculptor Alexander Calder, change was slow particularly

1932: Reconstruction Finance Corporation is set up in U.S.

1933: Franklin Delano Roosevelt becomes president. Wheeler-Howard Act passed to encourage cultural and economic development on Indian reservations. Hitler comes to power in Germany. One-quarter of the U.S. workforce is unemployed. New Deal policies are set up.

1935: Works Progress Administration is set up.

1930–39 A.D.

1932: Dorothy Dunn sets up the Studio in New Mexico. The Group of Seven disbands.

1933–45: Artists find work in the W.P.A.

1933: First European artists flee Nazi Europe and many settle in New York. David Smith makes his first welded metal sculptures.

1934: Hans Hofmann opens an art school in New York.

1935–56: Josef Albers becomes a member of the art department faculty at Black Mountain College, North Carolina.

1941: The U.S. enters World War II.

1942: The Manhattan District Project to build the atomic bomb is started.

1943: W.P.A. is shut down.

1945: Harry S. Truman becomes president. U.S. drops bombs on Japanese cities and World War II ends. After the war a baby boom begins and continues until the 1960s.

about 1946: The Cold War begins.

1940–49 A.D.

1940: Most of the Surrealist artists and others work from New York and other parts of the U.S. Peggy Guggenheim opens Art of This Century gallery in the 40s.

after 1945: Most European artists leave the U.S. and return to Europe.

1947–53: Abstract Expressionists working in New York make a breakthrough in modern art.

1950: Senator Joseph McCarthy begins his campaign to find Communists and their sympathizers in the U.S.

1950s: U.S. teenagers begin to set styles in a fashion boom.

1953: Dwight D. Eisenhower becomes president.

1954: Thurgood Marshall successfully argues before the U.S. Supreme Court that educational segregation is unconstitutional.

1950–59 A.D.

about 1950: Abstract Expressionist painters divide into two groups: Action Painters and Color Field Painters.

1951: Eleanor Ward opens the Stable Gallery in New York and gives Robert Rauschenberg and other young American artists their first shows in the 1950s.

1954: Pop Art bursts onto the New York art scene.

when it came to getting the American public to accept a modern American art. After the Armory Show lots of experimentation among Americans took place in the arts based mostly on modern European models of Cubism, Expressionism and Fauvism. The distance from Europe and the lack of first-hand information about theory or even what this art looked like due to the build-up of and then the start of World War I, possibly discouraged many American experimenters. Many gave up working with abstract art, destroying many of their valuable experiments, making the period from about 1913 to the 1920s a black hole in the development of some American artists. Art historians find this a particularly difficult period to trace because of the missing evidence. Many Americans, including artists, simply gave up after their idealism was shattered after World War I and life became increasingly difficult as the Wall Street crash of 1929 approached.

Between the 1920s and 1940s, many American artists went back to working in a realistic style. American Scene Painting's great figures—Edward Hopper, Charles Burchfield, Thomas Hart Benton, John Steuart Curry, Grant Wood and many others—created works based not only on what they saw around them but also reflecting the atmosphere of great change in America before World War II. In the 1920s the rise of black nationalism and a growing pride in their African heritage by black Americans was inspired by such figures as W. E. B. Dubois, Marcus Garvey and others. A blossoming of the arts—music, poetry, fiction, painting, sculpture—in Harlem called the Harlem Renaissance burst forth. At the same time, some Canadian painters were looking at the beauty of their huge, unspoiled country as inspiration for their new painting styles. The Group of Seven formed in Canada in 1920, disbanding again in 1923.

1961: John F. Kennedy becomes the youngest U.S. president. The Berlin Wall is built.

1963: President Kennedy is assassinated on 22 November and Lyndon B. Johnson becomes president.

1968: Police riots break out at the Democratic National Convention.

1969: Richard M. Nixon becomes president.

1960–69 A.D.

1960–63: Pop Art flourishes. Art becomes big business.

1962: Museum of American Folk Art opens in New York.

1964: Robert Rauschenberg becomes the first American to win the top prize at the Venice Biennale.

Mid-60s: Rise of Photo-Realism.

Late 60s to 70s: Minimal Art movement.

1970: On May 4 four Kent State University students protesting the Vietnam War are killed by Ohio National Guardsmen.

1974: President Nixon resigns office because of the Watergate scandal and Gerald Ford becomes president. Ford pardons Nixon.

1977: Jimmy Carter becomes president.

1970–79 A.D.

1970s–80s: Conceptual Art, Bodyworks, Performance Art, Environment Art, Earthworks,, Video Art, etc. and art using any material, discipline and technology becomes popular.

1974: *The Flowering of American Folk Art 1776–1875* exhibition is held.

1980s to 90s: Sophisticated technology becomes available to the consumer. The AIDS crisis begins.

1981: Ronald Reagan becomes president.

1989: George Bush becomes president.

1980–89 A.D.

1980s: Decorators begin to use Folk Art to capture the look of "American Country Style". Rise of Postmodern Art. Government art funding comes under attack.

1989: Robert Mapplethorpe exhibition is canceled at the Corcoran Gallery.

The Depression in the U.S. touched every American, for one-quarter of the American workforce was unemployed by 1933, the year Franklin Delano Roosevelt (1882-1945) became president. Artists were no exception. When President Roosevelt put his New Deal programs into action after his inauguration, American artists formed one group he wisely put to work. When money was appropriated in 1935 to start the Works Progress Administration (W.P.A.) artists, writers, engineers, architects and musicians went back to work doing what they had been trained to do. This program not only kept the arts alive in America during the difficult ten years of the Depression, but unknown to Roosevelt at the time, his programs ensured that when the U.S. entered World War II in 1945, engineers and designers with training were ready to help the war effort.

1990s: Women's rights, sexual harassment and abortion become big issues. Many Americans lose their jobs as corporations downsize.

1992: Bill Clinton becomes president.

1990 A.D.–present

1990s: Art is made and sold on-line by computer.

1994: An estimated 500 artists deal with the theme of AIDS as the central issue in their work.

More important, however, the W.P.A. brought artists together into a community where they could talk about their work, probably for the first time in any organized way in American history. In New York City, this association had an explosive effect when combined, during the years of World War II, with the presence of some of the great figures of European modern art in America. Refugees, among them many artists, began to arrive in the U.S. to escape Nazi Germany's horrors in 1933. A few refugee artists—Josef Albers, Hans Hofmann, Piet Mondrian—actually taught and worked with young American artists. This must have been a tremendous experience and it was something American artists never experienced before on native soil. More distant was the large group of Surrealist artists, who generally remained aloof to the contemporary American art scene and its artists. However, American artists paid attention to the ideas of the Europeans and to the way they seriously conducted their eccentric lives and expressed their ideas. Some New York artists were given the opportunity by gallery owner Peggy Guggenheim to show their work alongside these European figures. The center of the art world began to shift to New York from Paris with the arrival of these European artists. When most European artists returned to post-war Europe, the reason for the permanent change of focus in the art world was due entirely to the innovative work of the New York painters.

In an atmosphere of post-World War II social crisis, a new, confident, energetic and truly American way of making art exploded onto the scene in New York City. The Abstract Expressionists somehow unlocked the door for American art. The American artist and architect Tony Smith (1912–80) said that seeing the early work of the Abstract Expressionist painters in the late 40s was like ". . . crossing the desert and suddenly seeing the great gate of a

mosque—the only other experience in art that's really comparable." Everything changed with the work of these artists. Paintings began to be made on the floor, paint was now applied to canvas in unorthodox ways without a brush and the sizes of the works became larger and larger. American sculpture at the same time began to mature into a dynamic medium using modern materials, methods and large scale. From the 1950s until the end of the century American artists embarked on a period of constant creative discovery in which most of the old methods, materials and reasons for making art were pushed aside.

The breakthrough of the Abstract Expressionists brought American art international recognition. For the first time European artists began to look to New York for new ideas and the change and ideas in art never stopped in the second half of the twentieth century. Pop Art burst on the New York art scene and spread internationally particularly to Canada and Great Britain in the mid-1950s to early 1960s. The New Realism pursued the Pop artists' candidness and unsettling honesty and directness in the mid-60s. Minimal Art of the 1970s moved in yet another direction as American artists used industrial materials in their work and as the difference between painting and sculpture became more difficult to see. Minimal artists wrote criticism of their own work and actively sought support for their work from critics for the first time.

As the 70s progressed, art in America was no longer what it had been in 1900 to Robert Henri and the Eight or even a man with such foresight, as Alfred Stieglitz. Art became the idea, and not its representation in form. It became a process that simply took place during a period of time. Art could now be an action, a performance, the written word, a photograph, an earthwork, a video, a light and sound show or a combination of any of these things. Artists used every material, medium and method—including new technology—to make their art beginning in the 60s and 70s.

Although life in America from about the mid-1960s onward was a very troubled time as every human value and established way of thinking was questioned, actively challenged and sometimes changed, it proved to be a very exciting time for American artists. America suddenly began to value artists and their work. Starting in the 1960s it became possible for some artists to actually make a living from selling their art as art became big business. Some young artists such as Andy Warhol, Robert Rauschenburg and Jasper Johns became rich, international celebrities. Art education began to be encouraged at every level beginning in the 1960s. Government and corporate funding and other types of support for artists, special projects and exhibitions were made available to many beginning in the 70s.

As big business and the government began to see the cultural and political importance and even the power of art in American culture, in the 1980s and 1990s Postmodern artists began to question their world and their role in it. Postmodern art became a means for artists to search for identity and in small ways perhaps to bring about change regarding such issues as AIDS, race, sexual politics and the environment. Postmodern artists questioned not only the world but what art had become and the part it played in the larger world, just as Robert Henri and the Eight, Alfred Stieglitz and his artists, and the early post-Armory Show experimenters did in the first years of the twentieth century. The American poet Carl Sandburg (1878–1967) wrote, "Nothing happens unless you dream." The dream of many for a native, thoroughly American art that was also an expression of the times became reality in the twentieth century.

1 American Indian Art

No Art, No Artists

It would be difficult to find the words "art" or "artist" in any of the hundreds of American Indian languages. Making and decorating everyday and religious objects was necessary to carry on everyday life and many traditions. The work was sometimes a team effort based on instructions passed down from the elders in a tribe. American Indians never signed their work, or at least not until Europeans and white Americans began to be interested in it as souvenirs, exotic collectible objects or anthropological and archeological specimens. The work of the American Indians then began to be labeled as "art". ■

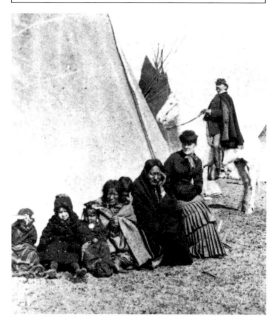

▲ *This photo was taken of Sitting Bull (third from the right), a squaw and his three children in 1882. They pose on the Standing Rock reservation with two white visitors who probably organized the picture-taking to provide an unusual memento of the visit.*

It is estimated that in the 1490s, about 10 million American Indians lived in North America on the land stretching from today's Mexican border to the Arctic Ocean. They lived in over 1000 different tribal groups all over the continent. Between 1862 and 1890 the tribal way of life was finally destroyed by the building of the railroads, by buffalo hunters and the U.S. Cavalry. By 1900, it is estimated, fewer than 400,000 American Indians had survived.

The reservation system and the Dawes Severalty Act of 1887 were set up to try to resolve the U.S. Government's problems with these strong and persistent people. The Indians were given land they already technically owned and forced to live on it. Tribal life was dissolved. Most had traditionally lived as hunters, gatherers and traders. Now they were forced to survive by learning to farm land that was as the government knew, no good for agriculture. By law, the Indians were made to give up their religions, their languages and traditions. They were not only required to live with the white man, but to live like him too. Most important, they were denied their freedom.

In the first thirty years of the twentieth century Indian arts and crafts survived only because those who produced them had to sell the pottery, baskets, jewelry and rugs they produced to make a living. Tourists looking for some exotic memento of their travels provided a meager source of income for some. A few anthropologists, aware that an ancient way of life was rapidly disappearing, paid tribal survivors to produce traditional arts and crafts and to sketch the disappearing rituals and ceremonies that few outsiders had ever observed.

Indian arts and crafts were traditionally practiced to provide useful things for the tribe or for ceremonial purposes. Handmade objects, such as bowls, blankets and rugs, were now easily purchased in near-

A Vision of What Was to Come

Sitting Bull (approx. 1831–1890), the famous chief of the Hunkpapa Sioux, had great vision of what was to become of American Indian peoples at the turn of the new century. At 12 noon, on July 19, 1881 when he and the remaining 143 people of his tribe surrendered to U.S. military officials, he said: "I wish it to be remembered that I was the last man of my tribe to surrender my rifle. This boy has given it to you, and he now wants to know how he is going to make a living." ■

The Studio

In 1932 the artist and teacher Dorothy Dunn set up the first formal art school for American Indians in New Mexico. It was called the Studio. She encouraged more than 700 Indian artists to work in their tribal styles. The best known graduates are Harrison Begay, Joe H. Herrera, Oscar Howe, Allan Houser and Pablita Velarde. ■

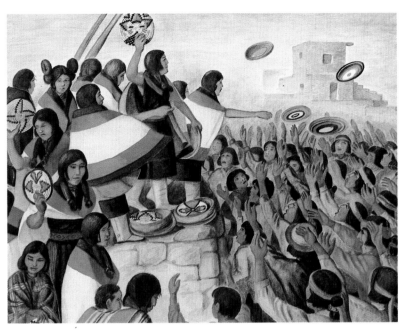

▲ *Fred Kabotie was the first Hopi Indian, to receive recognition as an artist in the 1900s. He painted* Basket Throwing *in watercolor. It shows Hopi women throwing harvest festival baskets into the air.*

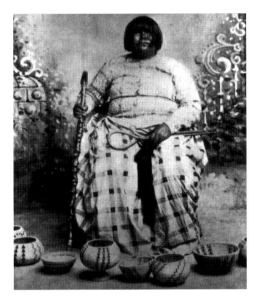

▲ *Dat So La Lee (1835 or 1850–1925), a basket weaver of the Washo tribe adapted her work to the demand of her customers.*

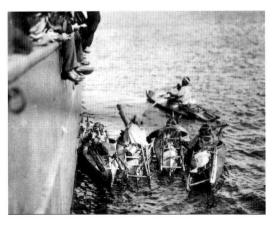

▲ *These Bering Strait Inuit, about 1900, are selling goods they produced from one-man kayaks, to passengers on the steamship Roanoke.*

by towns. Machine-made materials began to be used, instead of man-made ones, to save time. Indians from every tribe always decorated their belongings with colorful, images of plants and animals or made carvings from nature. Experienced members of the tribe would teach the method, style and images to younger members. Styles did not significantly change until the tribal system was destroyed. Then artists and craftsmen began to produce what they thought would please their customers. Their art was no longer an expression of tribal spirit.

Some Indians began to produce objects in non-traditional ways, for the first time, using materials and methods of artists in white communities. One group, known as the Self-Taught Painters, worked near San Ildefonso in New Mexico from about 1910 to 1920. Artists such as Velina Herrera, Fred Kabotie, Crescencio Martinez and Awa Tsireh generally used watercolor on paper to paint images of tribal life and rituals. This group is considered the first generation of non-traditional painters.

In 1928, the Federal Indian Office, perhaps seeing the enormous problem the terrible government policies had created, began to encourage the Indians to produce arts and crafts for cash. It was not until the 1933 Wheeler-Howard Act that there was a positive attempt to reverse the damage created by forced assimilation into white culture. The government encouraged economic and cultural development on the reservations for the first time. By the time help came it was almost too late. Native arts and crafts barely survived and they began to reemerge as what the white community considered fine art.

2 Early Photography

The Ten Cent Magazine

Begun in the 1890s, the ten cent magazines flourished in the early 1900s. *Collier's* and the *Saturday Evening Post* became the most popular. They were a bargain at ten cents because not only were they highly illustrated with color pictures and photos, they were well designed and featured society tales and love and adventure stories by some of America's greatest writers: Jack London, Frank Norris, O. Henry, Will Rogers, Mark Twain and Edith Wharton. ■

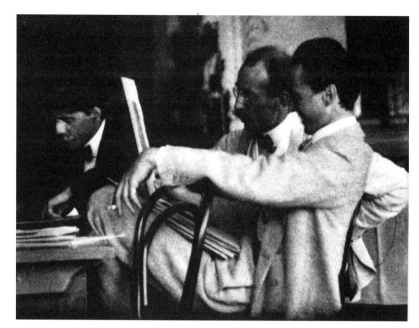

▲ *One of the greatest experimenters with photography was Frank Eugene. Eugene took this photo of Stieglitz (left), the painter, Walt Kuhn (center) and Steichen (right) at Gallery 291, discussed in chapter four, in 1907. An editor of* Camera Work *described Eugene's method of work: "He apparently rubs away the scratches, the secondary highlights that he desires to subdue; and he uses pencil and paint on the shadows he would lessen or lighten. He modifies and changes details in the same way, and all with a frank boldness."*

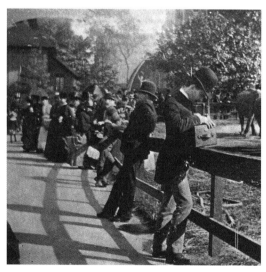

▲ *Alfred Stieglitz, the greatest of America's early photographers, observed in 1897, "Every Tom, Dick and Harry could, without trouble, learn how to get something or other on a sensitive plate and this is what the public wanted—no work and lots of fun." This amateur photographer is taking a picture of the elephants in Central Park in New York with his camera at the turn of the century.*

Americans at the turn of the century were obsessed with science and scientific invention. They hungered for information about the world that was changing so quickly. When photography, a French invention, reached U.S. shores in September 1838 it captured the American imagination. Photographic studios opened by the dozen in cities so that citizens of means could have their photos taken or arrange for family photos. Traveling photographers set up shop in wagons or buggies that served as darkrooms and worked throughout the fast developing western United States. Photography became a hobby of the middle class, as popular as bicycle riding, when smaller, easy-to-use cameras were made available.

By 1900, newspapers and magazines were replacing hand-drawn illustrations of news events with photos. The camera and the telegraph could now bring world events, reported and recorded by eyewitnesses, into the homes of subscribers. Photography became a successful commercial pursuit because Americans demanded to see more.

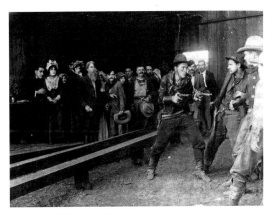

▲ *Movies, particularly westerns, became very popular with Americans after full-length versions were introduced in 1903. This is a still from the 1916 film* Hell's Hinges.

Social Reporters

Jacob Riis, working at the same time as the Photo-Secessionists, took photos to report on the terrible social conditions in New York City. Sweatshops, tenement life and the widespread poverty he observed as a police reporter made him very angry. He used his photos to make other people aware of how terribly slum-dwellers were suffering. He considered himself a reporter and nothing else. Today we consider Riis's photos works of art. Arnold Genthe, Lewis B. Hine and Frances Benjamin Johnson were other photographers who exposed bad conditions of U.S. cities through their photographs. ■

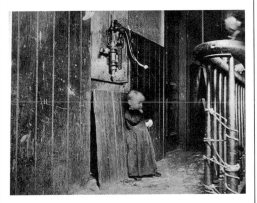

▲ *Jacob Riis took this photo in a New York City tenement.*

Opportunities for Women

New technology in the early 1900s created jobs for women. The camera, telephone and typewriter were new inventions that required little training and certainly no college education. Women, considered more polite than men, were preferred as telephone operators. Secretarial jobs were the domain of men who would deal with correspondence and act as company representative. This job could now be split in two. Women were offered the lower paid job of typist. The camera allowed women with little or no training to pursue an artistic interest. All these activities were considered "respectable" and helped women get out of the home and into the workforce. ■

Simple machines like the typewriter that were easy to use changed ▲ *life for many women. Secretarial jobs became respectable work for women.*

By 1900 some of the mystery and novelty of the photographic process had worn away and artists began to experiment with it. Alfred Stieglitz (1864–1946), considered the father of American photography, with other photographers wanted to make photography a separate and respected art form. In 1902 Stieglitz resigned from the Society of American Photographers. He started a magazine, *Camera Work*, opened an art gallery with his friend and fellow photographer Edward Steichen (1879–1973) and formed a photographic society called the Photo-Secession. He invited like-minded photographers to throw off conventional ideas of what a photo should be and join him. The gallery provided a place for many of the photographers to show their work. Of the 105 members, twenty of them were women. Some of the best known photographers in the group were Alvin Langdan Coburn, Frank Eugene, Gertrude Käsebier and Clarence H. White.

Social consciousness was not of interest to these photographers. They photographed romanticized scenes of America. Commonplace street scenes, machines and skyscrapers were photographed using a romantic, atmosphere-packed light. Much experimentation took place. Soft focus, underdevelopment, underexposure and work on the plate by hand were all processes with which many of the Photo-Secessionists began to work. They began to move away from the stark black and white of early photographs and toward an expressive abstraction.

3 | Robert Henri and the Ash Can School

Robert Henri (1865–1929) was the son of a riverboat gambler turned Nebraska business-man. He worked with a group of artists at the turn of the century in Philadelphia. By 1904, the whole group had followed him to New York City. In 1909 he opened an art school in New York's Hell's Kitchen. At a time when immigrants were streaming into American cities, these artists painted realistic, straightforward pictures of everyday life using deep colors and quick brush strokes. Henri and his friends painted overcrowded trains, sad city streets, tenement scenes and laborers at work and at play. This homely,

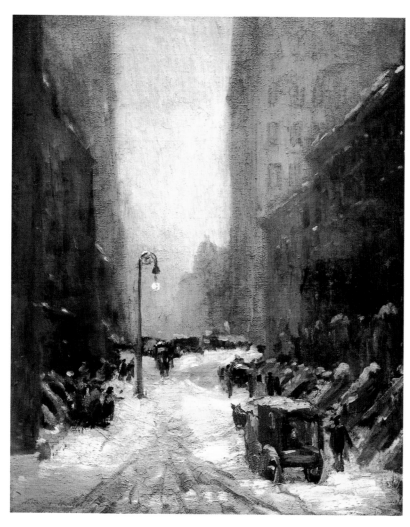

Snow in New York (1902) was painted in oil ▶ by Robert Henri, using rough, tough brushwork that reflects Henri's concern with the harsh character of much of urban life.

An etching of the Art Student's League studio by Marion D. Freeman, probably about 1905, includes Ash Can school members Robert Henri (third from left), John Sloan (1871–1951) (far left) and the artist (in the foreground). ▼

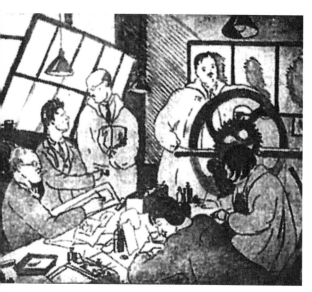

The Ash Can School at Work

Arthur B. Davies, William Glackens, Robert Henri, Ernest Lawson, George Luks, Maurice Prendergast, Everett Shinn and John Sloan were the eight members of this group. They painted using visual shorthand on any scrap they found handy. They composed and painted their pictures back in the studio from visual "notes" and from memory. To train their memories they followed strangers on the streets to study and memorize their movements. They played memory games. One member would leave the room and recall the room's contents. Four of them were illustrator/reporters and they all incorporated the reporter's unsentimental coolness in the scenes they painted. Their style was spontaneous. ■

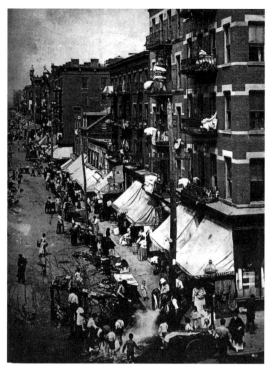

▲ *The reality of immigrant life is shown in this photograph of New York streets in the early 1900s, a favorite subject of the Ash Can School.*

Immigrants

Three-quarters of immigrants in the early part of this century settled in cities. By 1910, nearly fifty percent of the population of the U.S. cities was foreign-born. ■

American subject matter and the style in which they painted it, were not acceptable to the art critics and established art academies of the time and earned this group of artists the name of Ash Can painters.

The Ash Can school left a record of immigrant and city life that even today has a sense of immediacy. While the writers Frank Norris and Theodore Dreiser and the muckraking journalist, Lincoln Steffens, were demanding social reforms and fair treatment for workers, these visual artists had other things in mind. While sympathetic to these social causes, Henri and his friends were more concerned with creating a distinctly American art, which did not rely on the European traditions the art establishment demanded.

They used the fresh, contemporary images of American life, and rejected the rules and regulations of the academic art traditions of Europe because they thought them old-fashioned. The freshness of their images is such that one feels the paint has just dried. The brushstrokes are quick, and suggest the image—very different from the established academy painting. Just as immigrants, American writers and labor and social reformers, were struggling for change and equal treatment and when women were demanding equal rights and the vote, this group of artists was trying to create a more democratic, distinctly American art, using everyday life as their inspiration.

In February 1908, Henri and seven of his fellow painters organized a controversial exhibition of their work. The two-week exhibition was attended by 70,000 people. Though criticized for the down-to-earth subject matter of the paintings, the show was a commercial success. The show established the ideas of Henri and his friends, and the group was henceforth known as the Eight.

Progressives and Social Reform

The open, robust, informal character of the Theodore Roosevelt's (1858–1919) White House (he was president from 1901 to 1908) and identification with the reform impulse were inspirations to Robert Henri and the Eight. Progressive child labor legislation was in place in two-thirds of the states by 1907. The women's suffrage and trade union movements grew. Journalists such as Lincoln Steffens exposed corruption in the big cities and Ida Tarbell attacked dubious practices of big business. Governor La Follette of Wisconsin fought hard for laws requiring businesses in his state to comply with rules and be inspected in order to provide fair services for the people. ■

◄ *Teddy Roosevelt shown here in a typical pose, was an inspiration to the era of cultural and social reform.*

▲ *Ida Tarbell (1857–1925).*

◄ *Robert La Follette (1855–1925).*

4 Alfred Stieglitz and Gallery 291

An Eye for Winners __

Alfred Stieglitz had a knack for discovering artists that is rare. He was the first to show in America Cezanne's watercolors, Rousseau's paintings, Matisse's sculptures and works by Toulouse-Lautrec and Picasso. He gave the Europeans, Picabia and Brancusi their first one-man shows. He gave these American artists their first exhibitions in America: John Marin, Marsden Hartley, Max Weber, Arthur G. Dove, Abraham Walkowitz, Oscar Bluemner, Elie Nadelman, Georgia O'Keeffe and Stanton Macdonald-Wright. He also presented the first serious exhibitions of drawings by children and sculptures by black artists in America. ■

▲ *Georgia O'Keeffe, who painted this watercolor,* Light Coming on the Plains III *(1917), was given her first one-woman show at 291 by Alfred Stieglitz, who later became her husband.*

The photographer, Alfred Stieglitz, like Robert Henri and the Eight, was opposed to the standards the National Academy of Design imposed on art at the beginning of the century. But his ideas of modern American art were much more advanced than Henri's. In 1905, Stieglitz and his friend, the painter/photographer Edward Steichen opened a gallery in the attic of a brownstone at 291 Fifth Avenue in New York City which they officially called the Little Gallery of the Photo-Secession, more familiarly known as 291.

Stieglitz was a man of vision. With an exhibition in January 1908 of fifty-eight watercolors by the French artist August Rodin (1840–1917), Stieglitz became the first person to show work by a modern artist in America. He was also the first person to bring works by other important European artists to America such as Constantin Brancusi, Paul Cezanne, Henri Matisse and Pablo Picasso.

Many American artists and writers had moved to Paris in the early years of the new century in search of a place where they could express themselves freely. As many drifted back to New York, Stieglitz's gallery provided the center in America for avant-garde art and ideas. Stieglitz gave support and exhibitions to the new art of American artists such as Charles Demuth, Arthur B. Dove, Marsden Hartley, John Marin, Alfred Maurer and Georgia O'Keeffe. He provided a place to show and discuss ideas, and his support for his artists was unwavering.

Stieglitz never received much support for his ideas. The audience for avant-garde art was small, in part because the public was not made to feel welcome in the gallery. 291 was like a private club where Stieglitz protected his ideas and his artists. He was never much interested in

Georgia O'Keeffe _____

When Stieglitz was shown a group of charcoal drawings produced by Georgia O'Keeffe (1887–1986), he was delighted with the work and he exclaimed, "Finally, a woman on paper." Stieglitz became O'Keeffe's art dealer and eventually her husband. She was to become the model for many of his photographs.

She rebelled against the way she was trained as an artist. She said her training made her feel that there was nothing left to paint. O'Keeffe used bold colors and powerful shapes in her work to ". . . say things. . . I couldn't say in any other way— things that I had no words for." She was one of the pioneers of avant-garde painting in America and an innovative artist. ■

Expatriates

Until World War II, Paris was the center of the modern art world. A great number of young Americans and Canadians, frustrated by the stale atmosphere and ideas they found in America, flocked to Paris in the early 1900s.

The most famous Americans in Paris at this time were the Steins. Gertrude and her brothers Leo and Michael moved to Paris in 1903. They began to buy modern art in 1905 and became avid collectors. Their homes were places where artists could meet and became the base for Americans in Paris. ■

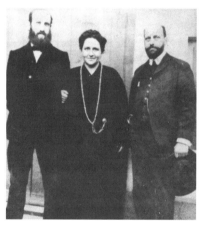

▲ *This is a photo of the Stein family taken in Paris in 1907. From left to right are Leo, Gertrude and Michael.*

▲ Equivalent *(1923) is an example of Alfred Stieglitz's move toward abstraction in his work.*

▲ *This 1910 oil on canvas,* Abstraction Number 2, *by Arthur G. Dove (1880–1946) is considered the first abstract, non-representational painting produced by an American. Stieglitz gave Dove his first one-man show. Dove said of Stieglitz, "I do not think I could have existed as a painter without that super-encouragement and the battle he has fought day by day. . . . He is without a doubt the one who has done the most for art in America."*

making money from selling art. The gallery always seemed short of funds. Stieglitz saw himself joined with his artists in a serious fight for intellectual and creative freedom. He said he was ". . .trying to establish for myself an America in which I could breathe as a free man."

Ironically, Stieglitz was left out of the preparations in 1912, by Robert Henri's group and others, for an exhibition of modern art called the Armory Show. This show exposed the general public in America to modern art for the first time. It was the Armory Show of 1913 that would give some publicity to the avant-garde art that Stieglitz promoted at 291.

After eleven exciting years, the gallery closed down because Stieglitz and Steichen found it impossible to transport art to New York from Paris with the outbreak of World War I. In a very short period of time the gallery and Stieglitz had both become legends for young artists. When the doors closed at 291 in 1917, modern artists had nowhere to go. They lost their audience. Most of Stieglitz's artists went off in separate directions. Stieglitz resolutely continued his own work in photography and his support for the artists whose work he guided. He has remained the most important figure behind America's early avant-garde tradition in art.

5 The Armory Show of 1913

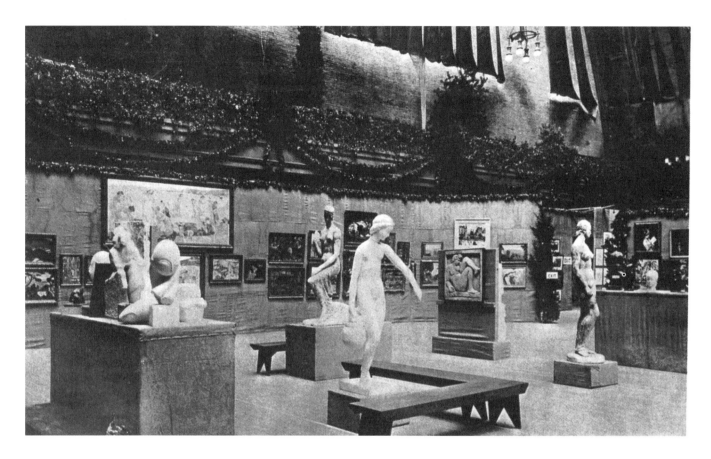

▲ *On February 17, 1913, the Armory Show, the most important event in modern American art, opened in the armory of New York's 69th Regiment. The show organizers described it as "revolutionary." About 1,600 works of art were displayed. The Americans represented were artists whose work was usually ignored. Works by European artists such as Pablo Picasso, Paul Gauguin and Henri Matisse were like nothing the Americans had ever seen. Former President Teddy Roosevelt was one of the 300,000 people who viewed the show, which opened in New York, traveled to Chicago, and finally closed in Boston. Roosevelt's reaction was similar to that of most visitors. He thought that this was a good opportunity to see works by young Americans, but he was not prepared to accept the work of the "European extremists."*

When the doors of the Armory Show opened on February 17, 1913, little did the organizers know that because of this exhibition, American art would never be the same. It was organized by a group of twenty-five painters and sculptors, the newly formed Association of American Painters and Sculptors (A.A.P.S.), led by their president, the painter Arthur B. Davies (1862–1928). The intention of the exhibition was to promote new kinds of art free of the old-fashioned rules of the National Academy of Design.

The armory of New York City's 69th Regiment on Lexington Avenue was rented for one month. Davies approached his wealthy art patrons for financial support. The painter William Glackens (1870–1938) was asked to choose the American art to be displayed. Davies sent the painter Walt Kuhn (1877–1949) to Cologne, Germany, in July 1912 to view an exhibition of modern art Davies had read about. Kuhn arrived the day the exhibition closed. He chose some works and moved on to Holland and then Paris to find more. The art connoisseur, critic and great promoter of the Armory Show, Walter Pach, guided him through Paris's modern art scene. Davies

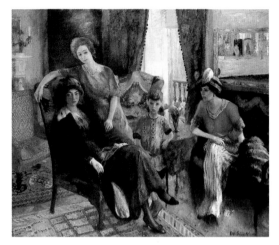

▲ *The patterns and bright colors of William Glackens's* Family Group *(1910–11), a painting in oil look very calm and quiet even though this painting is more than six feet/about two meters in height.*

American Versus European Art____

One-third of the Armory Show works of art were foreign and these were mostly French. Major names from Europe included artists such as Pablo Picasso, Henri Matisse, Francisco de Goya, Eugene Delacroix, Vincent Van Gogh and Paul Cezanne. One critic described the foreign works as "Ellis Island Art," meaning it was full of foreign influences being brought to the United States by immigrants. The American public had never seen anything as modern and as shocking.

Glackens commented: "I am afraid that the American section will seem very tame beside the foreign section. . . ." He was right. The show, nonetheless, was successful for it educated the public about foreign art and opened the art market to include young Americans. ■

▲ *Glackens's painting (above) looks ordinary compared to Henri Matisse's* The Red Studio *of 1911.*

joined Kuhn in Paris in October 1912 to help. They worked for ten days in Paris and moved on to London. On November 21, they returned to New York to organize the exhibition space, publicize the show and to prepare the guest list and catalog. The catalog contained 1,270 items though it is estimated that 1,600 American and European works of art were actually shown.

This was the first time that artists, art lovers, and the general public had the opportunity to view a large exhibition of modern American and European art in the United States. No major exhibition of modern art had been staged for the general public since an exhibition in 1880 of French Impressionist paintings. Walter Pach said that in 1913, there were no more than one hundred Americans who knew anything about modern art.

The average American had never seen anything like the paintings, prints and sculptures they encountered in this show. The flatness of

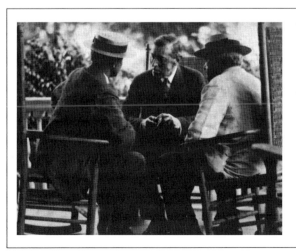

Woodrow Wilson: Leading America in Transition_____

A month before the Armory Show, Woodrow Wilson (1856–1924) was inaugurated twenty-eighth president of the United States. The nation was in transition and required a dynamic, innovative leader. It got one. Intelligent and principled, President Wilson initiated long-lasting social and economic reforms. ■

◀ *President Woodrow Wilson conferring with two of his aides.*

▲ *Marcel Duchamp's painting in oil on canvas,*
Nude Descending a Staircase, No. 2 *(1912), was
the hit of the Armory Show. The American public
had never before seen anything like this modern
painting that continues to be a popular work.*

The Star of the Armory Show

Teddy Roosevelt compared it to a Navajo blanket. One magazine held a contest to find the "nude" in the painting. A popular description was that it represented an explosion in a shingle factory. Someone also saw it as a "staircase descending a nude." Marcel Duchamp's *Nude Descending a Staircase*, *No. 2*, received much of the press attention and public reaction. One supportive critic, disgusted by the harsh criticism, said that all this nonsense was like looking for the moon in the "Moonlight Sonata." ■

space and wild colors of Henri Matisse (1869–1954), the Cubist abstraction of the painters Marcel Duchamp (1887–1968) and Georges Braque (1882–1963) and the boldness of Pablo Picasso's (1881–1973) paintings were a shock to the average American's visual sense of what a work of art should be. Not only the public, but American artists were confronted by a whole new way of making art and of looking at space, color and composition. In comparison few of the American contributions could be described as modern. The American work looked worn and faded compared to the shock to the senses the Cubist and Fauve paintings from Europe inspired.

All reactions to the show were strong, for the art shown *was* different. The public was reluctant to accept this modern European art, but still very curious to see it. In New York, Chicago and finally Boston, 300,000 people viewed the exhibition over a ten-week period. The large turnout was no doubt due to the excellent advance publicity for the show. The reactions of the public reported in every major newspaper and the reviews of art critics also helped to draw large crowds.

While the work of Marcel Duchamp and Constantin Brancusi drew

Collectors

The Armory Show marked the beginning of art collecting in America. Some entrepreneurs plundered Europe's art treasures. Others were interested in buying art produced by Americans. Some collectors—Dr. Walter Arensberg, Albert Barnes, Lillie P. Bliss, Katherine Dreier, Arthur J. Eddy, Duncan Phillips, Gertrude Vanderbilt Whitney—purchased works from this landmark show. Their collections are parts of American cultural institutions today. ■

▲ *Gertrude Vanderbilt Whitney
(1875–1942), opened a small museum in
1914 in New York City, which became
today's Whitney Museum of American Art.*

*Henry Clay Frick's (1849–1919) art collection, hung ▶
today in his mansion in New York City, is open to the public.*

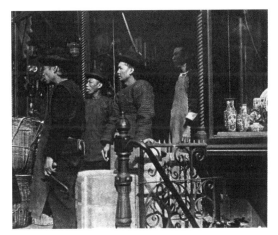

▲ *No immigrant group seemed more foreign to Americans than the Chinese captured in this period photo taken in New York's Chinatown.*

Immigration and Assimilation

As American art attempted to take in European ideas, the nation tried to take in or assimilate 13 million immigrants. The threat, perceived by some Americans, posed by this "invasion" was often expressed through contempt for anything foreign. Unions and strikes became symbols of the "foreign problem." Many immigrants arriving spoke little English and could not read or write. They clung to communities formed by friends and family. These communities worked hard to preserve ethnic identity and worked equally hard at self-improvement. Most immigrants learned to speak English quickly. Unions provided lessons in American government and English. Immigrants wanted to make life work in America. Their drive helped make America a giant economically. ∎

FEBRUARY 8, 1906

Dear Mr. Editor:

My own daughter, who was born in Russia, married a Hungarian-Jewish young man. She adopted all his Hungarian customs and not a trace of a Russian-Jewish woman remained with her. This would not have been so bad. The trouble is, now that she is first-class Hungarian, she laughs at the way I talk, at my manners, and even the way we cook. She does not avoid me. On the contrary, since her marriage, she has been calling on me even more than before. Not an evening passes without quarrels, without mockery and ridicule. I therefore want to express my opinion that Russian Jews and Hungarian should not intermarry: a Russian Jew and a Hungarian Jew are in my opinion two different worlds and one does not and cannot understand the other.

The Russian Mother

▲ *This letter to the editor published in a magazine in 1905 shows just one of the many problems faced by immigrant families living in America's cities.*

This strike scene recorded by an unknown ▶ *photographer shows what a melting pot the nation's industrialized cities had become.*

good-humored reactions, Henri Matisse's paintings were savagely attacked as "ugly, childish, absurd and indecent." In Chicago, it was reported that art students burned Matisse in effigy. Some critics, strongly opposed to all of the art, used words like "epileptic" and "anarchistic" to describe the show. The critic Kenyon Cox said, "If these painters represent our time, it means we are all going mad."

For all the criticism of the Armory Show, there were also many fans. The critic Hutchins Hapgood's review in the New York *Globe* was so enthusiastic that his article was moved to the newspaper's front page. A philosophy professor, Joel Spingarn, wrote in the February 25, 1913, edition of the *Evening Post* that ". . . the opening. . . seemed to me one of the most exciting adventures I have ever experienced. . . though it needs repeating in every generation. . . ." One artist told a reporter that the show made him want to live another fifty years.

Commercially the Armory Show was a success. Hundreds of items were bought by collectors. The show marked a turning point. American art and life were never the same again after 1913.

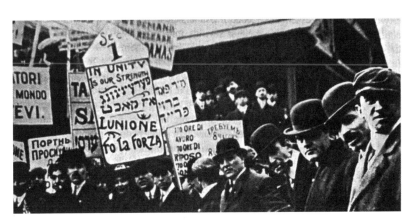

6 Experiments with Modernism

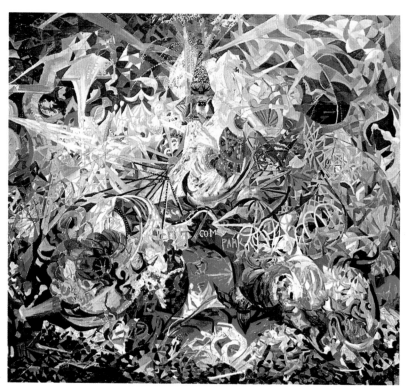

▲ *Joseph Stella (1880–1946) painted* Battle of Lights, Coney Island *in 1914 in oil on canvas. He drew on Cubist and possibly Futurist ideas to paint this wild image of America's most famous amusement park. The color and movement of the abstract shapes create a swirl of movement much like the way things are seen from a fast moving roller coaster.*

Katherine Dreier promoted an understanding of modern art in America with great energy. She joined forces with Marcel Duchamp and Man Ray in 1920 to form the Société Anonyme. They organized exhibitions, a traveling collection of art and gave lectures on modern art. She painted Abstract Painting of Marcel Duchamp *in oil in 1918.* ▼

After 1913, influenced by European avant-garde and abstract art, some American artists began to experiment and to change the way they worked. Many artists such as Arthur Dasburg, Stuart Davies, Arthur C. Dove, Jacob Epstein, Walt Kuhn, Joseph Stella, and even some of the Eight, all realists before 1913, began to incorporate the styles of Cubists, Fauves, Futurists and others into their work. Many American experiments in modernism were bad imitations and not very successful. In the hands of American artists, Cubism, for instance, was a series of strong lines and sharp angles fixed on top of the surface of a realistic image. No attempt was made to understand the thinking behind the work of European Cubist artists like Picasso and Braque.

Perhaps Cubism was not successful because of the timing of its arrival in America. American artists had no tradition to look to, to understand what Cubist artists were thinking. The idea of making a

▲ *Morgan Russell painted* Synchromy *(1914–15) in oil, based on theories about the ways colors react when placed next to each other.*

World War I_____

When Europe went to war in 1914 most Americans were shocked and disapproved. Led by President Wilson, Americans wanted to turn their backs on the war. When America entered the war In April 1917, most Americans agreed war was the only answer. When it ended in 1918, Americans wanted normalcy to return. ■

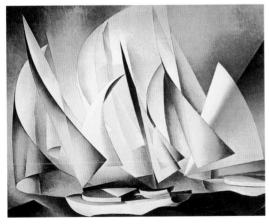

▲ *Charles Sheeler (1883–1965) painted* Pertaining to Yachts and Yachting *in oil in 1922. He disliked the way many American painters used fashionable abstract European painting as a model.*

painting without an image was also a new and shocking idea. The distance, about 3,000 miles/nearly 5,000 kilometers, from the European continent, certainly did not help. American artists found themselves isolated in a cultural vacuum. The start of World War I in 1914 and U.S. entry into the war in 1917 made direct contact with European Cubists and other modernists almost impossible.

Not all American experiments with modernism failed. The most successful American painters who used European modes were those that worked with color theory. Stanton Macdonald-Wright (1890–1973) and Morgan Russell (1886–1953) called themselves Synchromists. They successfully experimented with color theory in a similar way to that of the European painters, Robert Delaunay (1885–1941) and Frank Kupka (1871–1957).

Another group of painters known as the Precisionists found a successful way to merge European Cubism with American realism. They produced stylized and simplified images of bridges, factories and machinery and organized their paintings to emphasize purity of line and composition. Charles Demuth, Charles Sheeler and Joseph Stella were part of this group. Working with familiar American scenes helped these experimenters to succeed. They achieved a calm, solid grace in their work, an element missing from other contemporary American painting.

Some of the best artists of the post-Armory Show period were those who did not attempt to imitate the Europeans at all. The abstraction of their work seemed to come from an emotional response to their subject matter. Among these artists are Arthur C. Dove, Marsden Hartley, John Marin and Georgia O'Keefe.

After World War I, many American artists who had experimented with abstraction gave it up. Benton, Dasburg, Hartley, O'Keefe and Weber all went back to painting in a realistic way. Arthur B. Davies continued working abstractly, as did Stuart Davis (1894–1964), who was the only artist to carry the banner of modernism on to the next generation of American abstract painters. Other artists gave up all together. American artists had been trained to rely on the past. Perhaps some of them could not imagine being part of the future.

Some could find no direction or way to fit in. Making art was becoming an experimental, individual effort in America and no longer a group pursuit. Modernism was driven by a sense of adventure and of personal freedom. Idealism always pushed new ideas forward in America. After World War I, a large part of that idealism was shattered. The war had convinced some Americans that Europe was in decline. A lack of stability in art and American life took hold as Americans tried to put World War I out of their minds and as the stock market crash of 1929 approached.

7 | Painters of the American Scene

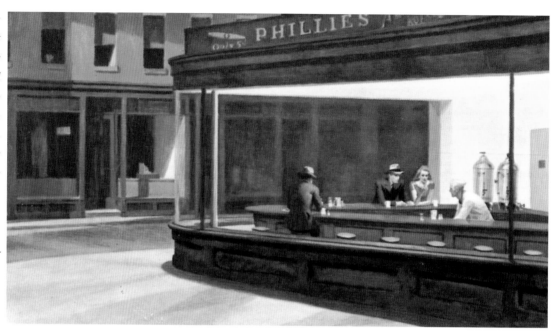

Edward Hopper is ► *perhaps the best known American scene painter. He investigated the psychology of the American experience in his work. His city scenes are moody and lonely. He painted Nighthawks, his famous work in oil on canvas, in 1942. The strange quality of Hopper's artificial light adds a little romance to this familiar scene.*

Arts in Harlem

Encouraged by W.E.B. DuBois (1868–1963), who helped to found the National Association for the Advancement of Colored People (N.A.A.C.P.), and Marcus Garvey (1887–1940) who formed the Universal Negro Improvement Association (U.N.I.A.), a pride in the black race and its African heritage grew in the 1920s. One result was a blossoming of the arts in Harlem. Black musicians, poets, fiction writers and artists found inspiration and strength in the Manhattan community of Harlem and black nationalism. The African-American poet, Langston Hughes (1902–67), captured the mood of hope Harlem provided for new arrivals to Harlem when he wrote: "I can never put on paper the thrill of the underground tide to Harlem. I went up the steps and out into the bright September sunlight. Harlem! I stood there, dropped my bags, took a deep breath, and felt happy again." ■

The American Scene Painters created a body of realist painting from about 1920 until the 1940s that represented a troubling commentary on what America was becoming. When World War I ended in 1918, Americans wanted to put the misery of that memory out of their minds and enjoy themselves. Business was booming in America and the middle class was expanding. Many families found they could now afford a car. More people sought job training and an education. People flocked to the movies and sports events, or enjoyed themselves by listening to the radio or dancing to the popular music called jazz.

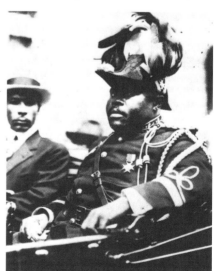

Born in Jamaica, the flamboyant ► *character Marcus Garvey, helped start the U.N.I.A. Garvey told a crowd of supporters in Harlem, "Africa was peopled by a race of cultured black men who were masters in art, science and literature." This was a man who made people think twice before they formed stereotypes of African-Americans. He and other outspoken black leaders helped inspire the Harlem Renaissance in the 1920s.*

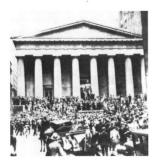

◀ *When the stock market began to crash on October 24, 1929, businessmen crowded Wall Street looking for news. The crash marked the start of the Depression.*

Too Little Too Late

Herbert Hoover (1874–1964) promised "a chicken in every pot and two cars in every garage" in his 1928 presidential campaign. He could not keep this promise when he was elected president that year. Once the miserable effects of the Depression became clear he cut consumer taxes, created some jobs through government programs and in 1932 set up the Reconstruction Finance Corporation (R.F.C.) to lend money to banks to help get them back on their feet. Help was offered to businesses but little if any relief trickled down to destitute individuals. Hoover—on good conservative principle—did too little too late to improve things. ■

Americans could not legally buy an alcoholic drink but could find one in the many illegal speakeasies that opened. A new openness about sexual matters developed. People flocked to the expanding cities in search of a bit of the good life and new economic opportunities.

At the same time the gap between rich and poor widened and old patterns of life in America began to disappear. Big businesses were unwilling to allow their profits to trickle down to the worker and became more determined to crush organized labor than ever before. The independent farmer and small business owner, once given credit for America's success, were now replaced by the corporate executive and the government bureaucrat. The movement to the cities created alienation, disappointment and tension as new arrivals found widespread bigotry and intolerance. Those left behind became resentful as it became more difficult to make a living from the land and as old ways and values began to disappear.

Americans found themselves caught in cross currents of conflict brought about by change. Most of the conflicts—old versus new, Anglo-Saxon versus ethnic, black versus white, business versus labor, corporations versus the individual, modern ideas versus traditional values—had long existed in America. Growth and change just emphasized the divisions. When the Depression took hold of American life in 1929, with the failure of banks and the Wall Street stock market crash, most Americans faced the biggest crisis of their lives. Many people lost their jobs, savings, homes, families, friends, social standing and self-esteem. Big business and the government ignored the plight of individuals for most of the ten years of the Depression. In 1933 with

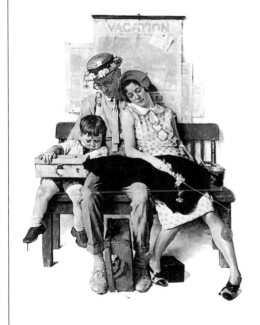

Norman Rockwell

The illustrator, Norman Rockwell (1894–1978), painted what could be considered the most accurate record of the American scene scanning a period of sixty years. Best known for his *Saturday Evening Post Covers*, Rockwell held a friendly and sympathetic mirror up to American life. Unlike American Scene painting, Rockwell's body of work from the 1920s to the 1940s is full of optimism. Perhaps this explains why the *Post*'s print order was increased by 250,000 copies whenever a Rockwell cover appeared. ■

◀ *Norman Rockwell was probably the artist who captured the American scene most accurately in the sixty years he worked. He not only recorded accurate details but also touched something in every viewer's life. That's perhaps why people still love Rockwell's nostalgic illustrations.* Home from Vacation *was the cover image of the* Saturday Evening Post *on September 13, 1930.*

The Death of Capitalism?

While many Socialists and Communist party members thought the Depression would bring about the death of capitalism, most Americans did not think so. Of course, some Americans blamed big business and the government for their troubles. Generally, however, Americans blamed themselves. Most people thought it was their responsibility to get through the Depression without handouts. They·were embarrassed by their hunger, poverty and lack of work. Americans did persevere and believed things would get better. It took a long time for things to improve. ■

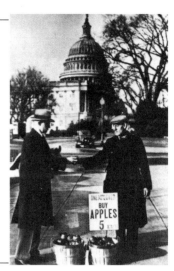

Americans blamed ▶ *themselves for their difficulties during the Depression. Most were determined to get through the tough times without accepting charity like this unemployed man who sold apples on a Washington, D.C. street.*

Charles Burchfield used small American towns as his inspiration. In Burchfield's hands small town scenes become strange and buildings and landscape elements take on a vegetable-like life with an energy of their own, like those in this watercolor, Church Bells Ringing, Rainy Winter Night *(1917) which are contorted and look haunted. His paintings are full of fantasy. He said his paintings were "... the expression of a completely personal mood."* ▼

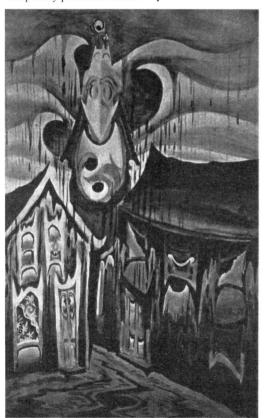

one quarter of the workforce, or 13 million people, out of work, Americans needed something to give them hope. Since life had fallen apart for most people the only thing they could fall back on was the past. Small town life, religion, the family, the home, hard work and the strength of individuals were the things most people felt had built America and this is where Americans looked for inspiration.

American painters, writers and intellectuals, caught in the cross current of European modernism versus American thinking, also looked back for direction. Few American artists had found a comfortable means of expression in their experiments with European modern art. Modern European ideas became viewed by most people as subversive, foreign propaganda. Artists felt that American art must find its own identity. The answer for most artists was to return to realism using the familiar images of the American scene and contemporary issues as inspiration.

Charles Burchfield (1893–1967) and Edward Hopper (1882–1967) painted stark scenes reflecting the dark side of life in America. While Burchfield drew inspiration from small town scenes, Hopper mainly focused on city life. Burchfield painted haunted·houses and empty street scenes full of contorted, sometimes grotesque, shapes that by the 1930s became tortured and took on lifelike qualities. In his paintings he expressed the demoralizing effects of small town life and sexual repression. Hopper painted mannequin-like figures in empty offices, lonely hotel rooms and deserted neon-lit cafes. Through these scenes he commented on the sadness, boredom and loneliness of city life. Each of these painters expressed the spiritual vacancy American life took on in the 1920s and 1930s. In the worlds each painted, all of life's zest seems to have disappeared. Only the difficulties of life— hard work, struggle, worry, tension, fear, loneliness—remain.

The Regionalists, unofficially led by Thomas Hart Benton (1889–1975), painted nostalgic images of the American heartland

Depression-Proof Successes

Although many businesses failed during the Depression, and farmers, farm laborers, factory workers and construction workers found few, if any, opportunities to improve their situations, some businesses grew during the Depression. The music industry prospered due in part to the creation of the thirty-five cent, 78 R.P.M. record and the jukebox. The radio and motion picture businesses were also Depression-proof. Americans looked for ways to escape the misery of their daily lives by entertaining themselves. ◼

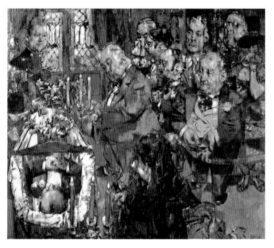

▲ *Jack Levine's excellent technical ability is evident in* Gangster Funeral, *painted in oil in 1953.*

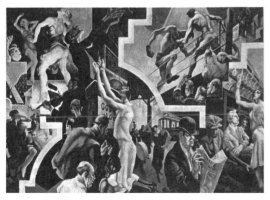

▲ *Thomas Hart Benton's giant figures in* City Activities with Subway *(1931) look like they might explode into the viewer's space.*

using classical painting traditions. John Steuart Curry (1897–1946) painted American folk heroes while Grant Wood (1892–1942) painted surrealistic images of country characters and scenes. Benton's paintings were filled with huge figures that pressed at the picture frame. They were melodramatic paintings about the changing American scene. The good guys in Benton's dramas were small businessmen, hardworking farmers or labor union members. The bad guys were politicians, big businessmen and city dwellers. The writer William Goetzmann has said that Benton organized the images in his paintings "... like the rotogravure pages of the Sunday newspaper...."

The Social and Romantic Realists also drew on classical painting traditions to produce everyday city scenes or portraits of the common man. Each artist worked in his or her individual style. Some of these artists were Milton Avery, Isabel Bishop, Edwin Dickinson, Philip Evergood, William Gropper, Yasuo Kuniyoshi, Reginald Marsh, Ben Shahn and the Soyer brothers: Isaac, Moses and Raphael.

Few of the American Scene Painters were good technicians. However, Hyman Bloom and Jack Levine were excellent technicians. Their work began to take on some of the characteristics by which American twentieth-century painting eventually became identified: strong statement, bright color and violent handling of paint.

Canadian Scene Painters

In 1920, seven Canadian painters—J.E.H. MacDonald, Arthur Lismer, Frederick Varley, Frank Johnston, Franklin Carmichael, Lawren Harris and A.Y. Jackson—banded together to form the Group of Seven. They joined together to explore the expressive possibilities that Canada's landscape had to offer. They painted Canada's northern landscape, coast to coast, at the same time U.S. painters were using scenes of their country as inspiration. The group disbanded in 1932. ◼

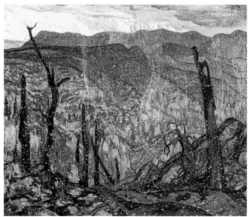

◀ *A.Y. Jackson (1882–1974), a member of the Canadian Group of Seven, painted* First Snow, Algoma *(1919–20) in oil on canvas. This group used bright colors and bold brushwork to paint the Canadian landscape.*

Works Progress Administration, 1935–43

Arshile Gorky's ▶ *(1904–48) sketch for a W.P.A. mural at Newark Airport in New Jersey is all that remains. Entitled* Aviation: Evolution of Forms Under Aerodynamic Limitations, *the mural, painted about 1936, was probably destroyed.*

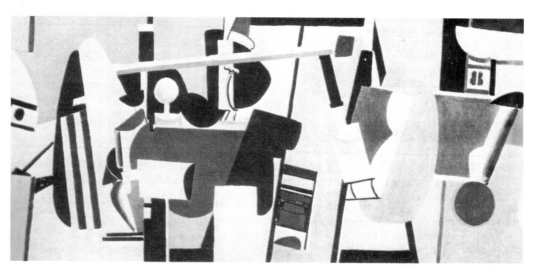

Irene Rice Pereira (1905–71) was employed by the W.P.A. as a teacher in several schools where she taught industrial design and composition. The project provided financial support for her and her family during the Depression, but she was also given the freedom to experiment in her own work. She used materials such as glass and cardboard, as in this work entitled Transfluent Lines *of 1946.* ▼

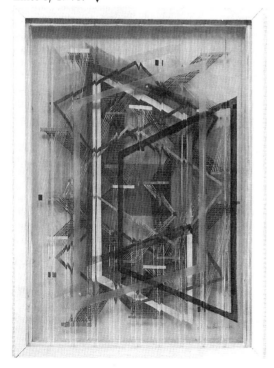

In 1932 Franklin Delano Roosevelt (1882–1945) the Democrats' nominee for president, announced at the Chicago convention, "I pledge myself to a new deal for the American people." Those gathered believed him and so did the 23 million Americans who elected him president in a landslide victory that year. Roosevelt created programs to relieve severe problems Americans faced due to the economic depression that began in 1930 and lasted ten years. Franklin D. Roosevelt's first presidential

▲ *C.C.C. jobs helped boost morale and gave the general public a sense that things were improving as in this Connecticut forestry project.*

Alphabet Soup

The U.S. government funded programs to provide jobs in the Depression years. The Civilian Conservation Corps (C.C.C.) employed 250,000 men in forestry, land and conservation projects. The Civil Works Administration (C.W.A.) put 4 million people to work teaching and constructing roads and buildings. The Works Progress Administration (W.P.A.) hired all types of artists. ■

term (1933–1937) was known as the New Deal, as his priorities were economic recovery and ending the Depression.

Roosevelt realized that the most pressing need was for jobs. By 1933, twenty-five percent of the American workforce or 13 million people were unemployed. To provide relief and jobs, Roosevelt appointed his close adviser and friend, Harry Hopkins (1890–1946), to set up various federal programs. One of the most effective was the Works Progress Administration (W.P.A.) established in May of 1935. The W.P.A. provided jobs for, among other people, artists, writers, engineers, architects and musicians. Following Hopkins's philosophy of "jobs instead of charity" the agency put talented people to work.

In 1935, murals funded by the W.P.A. began to appear in libraries, airports, train stations, and schools all over the United States. Much of the subject matter drew on scenes from American life for inspiration and glorified the worker and America's heritage. Some artists used the murals to express their personal, political philosophies. Others were paid to design tiles to decorate subway and train stations, to teach art and design and to photograph America's changing scene.

By 1943, when the W.P.A. was shut down, the government had spent $11 billion to employ 8.5 million Americans. Without this program, a generation of U.S. artists and the cultural history of this ten-year period might simply have disappeared. More importantly, America would have entered World War II with few young people with skills and few trained engineers and designers.

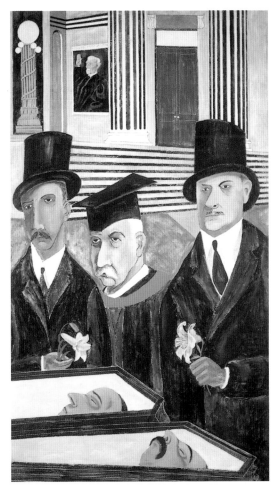

▲ The Passion of Sacco and Vanzetti *(1931–32), painted by Ben Shahn (1898–1969) in tempera, was typical of the social realism of the Depression era. Shahn protested against the treatment of the Italian anarchists, Sacco and Vanzetti, executed for murder in 1927 amid a great public outcry.*

Berenice Abbott's (1898–1977) project to record ▼ *New York City's changing scenes was funded by the W.P.A. Her photo record of New York life in the 1930s was published in book form and is a valuable historical document.*

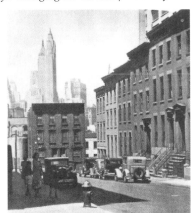

▲ *Eleanor Roosevelt acted as "the eyes and ears" of President Roosevelt (1933–45) focused on the nation. She helped keep Americans working during the Depression.*

F.D.R.'s Second

Among President Franklin Roosevelt's greatest assets was his remarkable wife, Eleanor Roosevelt (1884–1962). She was a human dynamo. During the Depression, when President Roosevelt's New Deal policies were introduced, Eleanor raced around the country meeting the "forgotten" people and reported back to her husband. She was a woman of great sympathy and compassion. She greatly influenced her husband's policies on the treatment of black Americans, women's rights, unemployment, housing and unions. ■

9 American Folk Artists

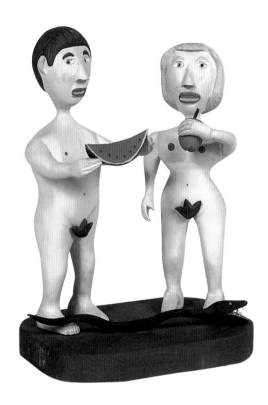

▲ *The carver, Bryan McNutt, creates whimsical figures in pine that he paints in bright colors. His figures, such as these of* Adam and Eve *have a lifelike quality in that their eyes seem to follow the viewer.*

▲ *"All That I Am or Hope to Be I Owe to My Angel Mother" by C. Lawson was painted in oil in 1978. The artist also painted the frame.*

Produced by artists with little or no training, American Folk Art has always been made in communities across the nation. Folk Art is not an art based on perfection and beauty, but generally is an emotional, straightforward expression of the artist's private, personal vision of the world. American Folk Art can be described in the same way some people describe the American character: brave, honest, bold, energetic, individualistic, emotional, spontaneous and sometimes a little naive. Although much of the work communicates something of the artist's personality, folk artists are not interested in painting in an accepted style. They simply get on with their work. The writer, Virgil Baker, said in a May 1954 article about early American Folk painters in *Art in America*: "Their makers apparently painted about as straight forwardly as they went to church and sang hymns, that is one reason for their present historical and spiritual authenticity."

Much Folk Art in America was and still is made simply to decorate walls; to keep a record of people in a community and of places where they live; to record important events or to make everyday objects more appealing. Put simply, it is an art of the people and the times, made for others to enjoy. At the same time, Folk Art has and continues to be a valuable social and economic record of everyday life in America. without nostalgic overtones. Perhaps for this reason until the 1960s Folk Art was most often categorized as "antiques" by art dealers. But as the writer E.P. Richardson was quick to point out in May 1950 in *Antiques* magazine: "American Folk Art is not Americana. It is art."

In 1924, the Whitney Studio Club held the first Folk Art exhibit called *Early American Art*. The exhibition included forty-five works—thirty-five by anonymous artists. Artists' names could not be attributed to most of the works because until this exhibition no biographical records had been kept. This was all to change due to active collecting of American Folk Art in the 1920s and 1930s.

Some of the early collectors in the 1920s were contemporary American artists such as Alexander Brook, Yasuo Kuniyoshi, Peggy Bacon and Charles Demuth, and the sculptors, Robert Laurent, William Zorach and Elie Nadelman. These enthusiasts were responsible for other exhibitions and publications which made a larger public aware of this once overlooked area of American art.

In 1932, the Museum of Modern Art staged an exhibition called *American Folk Art. The Art of the Common Man in America, 1750–1900*. Holger Cahill, who organized two other exhibitions on the same subject for the Newark Museum in New Jersey, produced

Many twentieth-century folk painters use ▶ biblical themes as inspiration, such as this painting entitled Noah's Ark *by Mike Perez, painted in acrylic on canvas in 1985.*

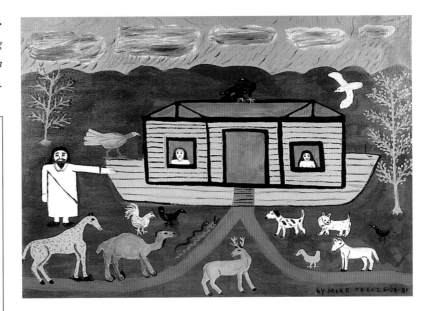

Recognition at Last___

Throughout history, American Folk artists have quietly worked away in every corner of the United States. Until the twentieth century, little notice was taken of their work. Folk artists are generally not competitive and don't seek fame but those who have received recognition in the twentieth century are generally delighted by it and enjoy it. ■

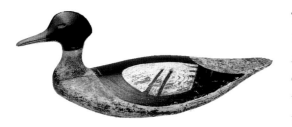

▲ *Decoys are one of the most popular forms of American Folk Art. Once carved to attract the prey of bird hunters, they are now highly collectible. This merganser was carved by George Huey (1866–1947) of Friendship, Maine. Huey was a small-town character who seemed to have inherited his artistic ability from his mother, Saltanny, who made models of local homes from shoe boxes.*

the catalog for this show, which today is still an important document used by Folk Art scholars.

The Museum of American Folk Art opened in New York in 1962. Then, after the 1974 exhibition *The Flowering of American Folk Art, 1776–1875,* staged fifty years after the first Folk Art exhibition in America, collectors, dealers and the general public began to look at everything around them made by American artists and craftsmen with very different eyes. Galleries opened in every major city throughout the U.S. American Folk Art became so popular that Folk Art and Folk Art motifs became the theme for interior decorators in the 1980s and 1990s who thought they captured the look required for "American Country Style" internationally.

Once anonymous and isolated, American folk painters, sculptors, carvers, weavers and quilters continue to work but only recently has their work been appreciated and recognized as something valuable produced by talented artists. American Folk Art in the twentieth century has found its place in American culture and internationally as more than a quaint relic but as a true art of the American people.

Public Collections ___

Mrs. John D. Rockefeller, Jr. began her important collection of Folk Art in the 1920s. That collection, along with that of J. Stuart Halladay and Herrel George Thomas, forms the nucleus of the large collection housed at the Abby Aldrich Rockefeller Folk Art Center in Williamsburg, Virginia. Others are the Lipman Collection acquired by the New York State Historical Association in Cooperstown, New York in 1950, and the Garbisch collection of paintings housed in the National Gallery in Washington D.C. and the Metropolitan Museum in New York. The Shelburne Museum in Vermont houses the eclectic collection of Electra Havemeyer Webb. All are open to the public. ■

Refugee Scientists

European scientists who came to the U.S. during World War II were key in encouraging the U.S. government to develop the atomic bomb. They helped to build bombs that destroyed Hiroshima and Nagasaki in 1945. This led to the end of the war in the Far East. In 1942 General Leslie Groves was put in charge of the Manhattan District Project—code name for the atomic bomb project. Two billion dollars were appropriated and 540,000 American and foreign-born people worked for three years until the bombs were ready to drop on Japanese cities. ■

Giorgio Cavallon (1904–89), one of the first American abstract painters in New York in the 1930s, studied with Hans Hofmann from 1934 to 1936 and was influenced by Piet Mandrian's work. This untitled oil on canvas of 1953 shows that influence in its structure and color. ▼

In 1933, when Adolf Hitler (1889–1945) came to power in Germany the persecution of minorities, Jews and intellectuals began. Many intellectuals, among them writers and artists, in fear of their lives, fled Europe for the United States. This provided American artists their first direct contact with some of the great figures of European art. As exiled artists poured into New York, the focus of the art world began to shift from wartorn Paris to New York City.

The art historian Barbara Rose said that when European refugees arrived in the late thirties ". . . abstract art in America was a voice crying out in the wilderness." Museums would show European abstract art, but not abstract art made by Americans, because the public was not interested in it.

Hans Hofmann (1880–1966) arrived in New York in 1934 and opened a school on Eighth Street. He had seen Cubism develop firsthand in Paris. He knew Pablo Picasso, Georges Braque, Henri Matisse, Paul Klee and Wassily Kandinsky. Young artists would come in the evenings to listen to Hofmann's impromptu lectures. Piet Mondrian (1872–1944), the Dutch painter, arrived in 1940. He, too, spent time with American artists, teaching and discussing his theories about painting.

Most of the Surrealists arrived in the 1940s. With great energy they began to organize events, to show their work and to publish Surrealist magazines—all geared to shock the public and attract publicity. The American Peggy Guggenheim (1898–1979) provided a way for young Americans to meet the Surrealists when she opened her art gallery called Art of This Century. It became a meeting place for artists. She also provided American abstract artists a place to show their work.

The Surrealists in New York formed a closed group and were not generous with their time. The Surrealists' goal was to change human

Fashion and World War II

The fashion world also felt a rumble of change in the direction of America during World War II. American fashion designers always looked to Paris to set styles but the fall of Paris to the Germans in 1940, forced American fashion designers to come up with their own new look. They did and it had longlasting effects. It proved that America could function independently of Paris paving the way for the 1950s fashion boom when the American teenager began to set international fashion styles. ■

Josef Albers

Perhaps the most influential European refugee to come to the U.S. was the teacher and painter, Josef Albers (1888–1976). He was a member of Black Mountain College's art department from 1933–56. Black Mountain College was an avant-garde center, sympathetic to testing new ideas in North Carolina. Many students feared Albers, but he opened their eyes. The school had a big influence on art and the American cultural climate of the 1960s and beyond. The Albers years brought faculty members Buckminster Fuller, Willem and Elaine de Kooning, Franz Kline, Robert Motherwell, Jack Tworkov, and John Cage. The artists Robert Rauschenberg, Kenneth Noland and John Chamberlain, and the dancer/choreographer, Merce Cunningham were Black Mountain students. ■

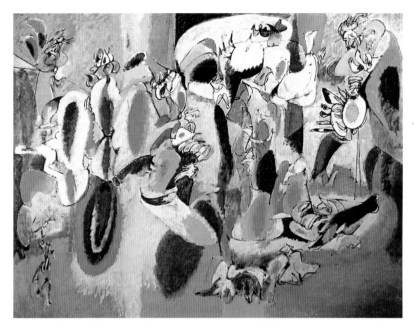

▲ *Arshile Gorky painted this oil on canvas, entitled* The Liver Is the Cock's Comb, *in 1944. Gorky diligently studied the works of Picasso, Matisse and Miró. He began to change his work after contact with the Surrealists which helped him express his inner thoughts and emotions.*

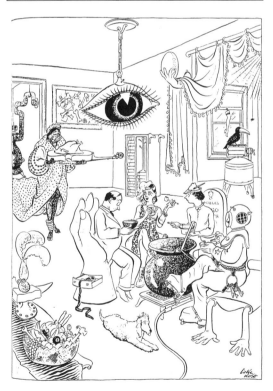

▲ *This cartoon, by Carl Rose, appeared in a 1937 issue of* New Yorker *magazine. The caption was, "A Surrealist Family Has the Neighbors in to Tea."*

life by exploring the unconscious. They used dream analysis, automatic writing and game playing to reveal hidden ideas in the human mind. They considered their work a very serious pursuit.

The difference in experience, intent and, in some cases, age provided the Europeans cause to not consider the work of the Americans very seriously. When the painter Max Ernst (1891–1979) reflected on his New York stay, he said, ". . . In New York we had artists, but no art." The artist Arshile Gorky was one of the few Americans taken into the exclusive Surrealist ranks. Gorky has in fact been called the last of the Surrealists and the first of the Abstract Expressionists, because his work in the 1930s and 1940s provided an important bridge between European and American art.

American artists, like Jackson Pollock (1912–56) and Willem de Kooning (1904–) were attracted to the element of play and the accidental nature of Surrealist attempts to tap the unconscious with automatic writing and drawing. The Americans gained confidence through their limited contact with the Europeans and began to realize they did not have to deal just with the past, particularly the European past, in their work. By drawing on their own inner energies they could move forward in making art that was truly American. After World War II ended in Europe in 1945, most European artists went home. The New York artists by then were on their way to creating art that was to change the way people thought about modern art throughout the world.

11 The Abstract Expressionists

Jackson Pollock is shown with Mural ▶
which he painted in 1943 in one day after
studying the blank canvas for six months.

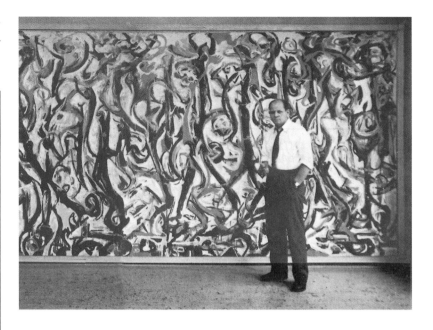

Looking at a Pollock ＿

Looking at a Pollock drip painting is a memorable experience, much like looking at the sky on a clear, dark, moonless night when you can see hundreds of stars and feel the great depth of space. Pollock created the illusion of depth in the tangled surface application of paint—a sort of optical illusion of space. Pollock could control the large spaces he painted. He said: "I have no fears about making changes, destroying the image . . . because the painting has a life of its own." The viewer can feel life and energy looking at a Pollock. Maybe this is what Pollock meant when he said he tried to integrate art and life in his paintings. ■

Sometime in 1947, the New York painter, Jackson Pollock, put a piece of canvas on the floor. He stood above the canvas. Using commercial house paint and sticks and old, dried brushes, he rhythmically poured and dripped paint on the canvas in thick, interwoven layers. He sometimes erased, obliterated or painted over and reworked the result. The paintings he produced were like nothing that any artist, anywhere, had ever produced. They broke all the rules of traditional

Jackson Pollock did a kind of dance as he dripped
paint on his canvases spread on the floor. ▼

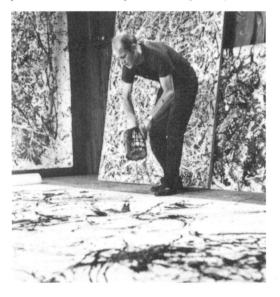

Innovators and Anarchists ＿＿＿＿＿

Between 1947 and 1953 the Abstract Expressionists found a uniquely American means of expression. This was no small accomplishment for generations of American artists had been struggling to achieve this. Because there were never any works of art like these before, it was not easy to understand Abstract Expressionism. It took a lot of intellectual courage to stand behind innovative ideas like these. One writer said that being an artist in this period was like making art in a bunker. The Abstract Expressionists were laughed at, called Communists and the influential critic of *The New York Times*, John Canaday, accused them of fraud and incompetence. This art represented anarchy and disorder for most people because it broke all the established rules. But for young Americans, these artists represented liberation and hope. ■

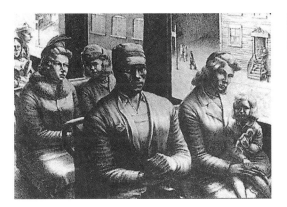

▲ *Black military veterans were bitter about a society that supported the fight against fascism abroad, but practiced racism at home. John Woodrow Wilson, a black artist, produced this etching in 1945 that sums up the alienation so many black Americans felt.*

Taking a Chance

As early as 1942–43, the gallery owner Peggy Guggenheim showed the works of Baziotes, Motherwell, Pollock and Reinhardt. When she returned to Europe after World War II, Betty Parsons took a chance on the work of these painters. In 1946 she opened the Betty Parsons Gallery and invited Rothko, Pollock and Still and eventually many others to show. These two women took a big chance when no one was interested in American abstract art and when the paintings often brought a response of hostility. Betty Parsons described what made her gamble on these artists: "Pollock really released the imagination of this country, freed the creative urge." Eleanor Ward opened the Stable Gallery in 1951. She gave Robert Rauschenberg (1925–) his first opportunity when she showed his all-white and all-black paintings in 1951. ■

Civil Rights Action

The uneasiness that descended on America after World War II particularly took hold in black communities. Blacks, like other groups after the war, thought there might be some hope for a better life and sought improvement. They organized to advance their interests with help from the N.A.A.C.P., the Congress of Racial Equality (C.O.R.E.) and through the power of the black vote. In 1954, Thurgood Marshall (1908–94), a lawyer who became the first black Supreme Court Justice, successfully argued before the Supreme Court that separating people racially in educational facilities represented unequal treatment and was unconstitutional. When Rosa Parks, a black secretary, refused to give up her bus seat to a white man in 1955 in Montgomery, Alabama as city law required, the Reverend Martin Luther King (1929–1968) organized a black boycott of Montgomery buses. King's work paved the way for the end of civil discrimination based on race in the 60s. ■

painting. No one had ever painted on the floor. The paintings were full of accidental drips and sometimes bits of newspaper, cigarette ash, broken glass or other discarded things would stick to the paint. The paintings looked primitive, unfinished and spontaneous. They were generally large and colorful. Some even described them as ugly. Their

Willem de Kooning painted Excavation *in oil on canvas in 1950. It is the kind of Abstract Expressionist work that seems to reach back to the origins of art when making art probably had something to do with power, magic and mystery.* ▼

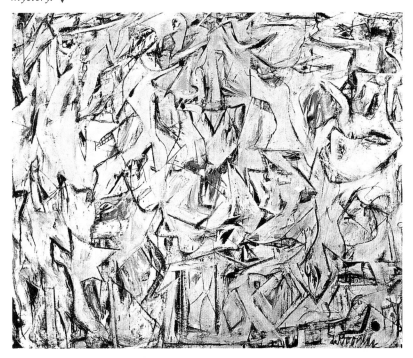

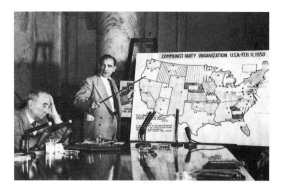

▲ *Senator Joseph McCarthy (1909–57 center), began a reckless campaign to find Communists and their sympathizers in America in 1950. McCarthy destroyed the lives of many people he falsely accused.*

The Cold War

During World War II, the United States and Great Britain were allies of the Soviet Union. Their common cause was defeating Nazi Germany. In 1945 the old wartime alliance ended. When the Russians prevented free elections in Poland in early 1946, the former English prime minister and wartime leader, Winston Churchill (1874–1965) made a speech in March 1946 in Fulton, Missouri. He said an "iron curtain" had descended around eastern Europe and that the Soviets were determined to expand Communist power and doctrines. A state of tension grew between the Soviet Union (and other Communist countries) and the United States and its allies, that lasted over forty years. It is known as the Cold War. Characterized by arms races, military build-ups and propaganda warfare, it stimulated U.S. anti-Communist feeling, influenced American politics and society particularly in the 1940s and early 1950s and was an important factor behind the foreign policies of every U.S. president from Harry S. Truman (1945–52) to George Bush (1988–92). ■

impact on the viewer drew emotion, for the wild, overall swirls of paint, spread on the surfaces of Pollock's large canvases seemed to envelop and draw the viewer with their energy and power. These "action paintings", as they were first called in 1951 by the critic Harold Rosenberg, changed modern art. Never in history had a new idea about art come from America.

At about the same time, many New York artists—Willem de Kooning, Barnett Newman, Jack Tworkov, Mark Rothko, Clyfford Still, Robert Motherwell, William Baziotes, Franz Kline, Ad Reinhardt and others—began making breakthroughs in their art. What was surprising was that these artists, most middle-aged and all used to working in conventional styles, changed the way they painted virtually overnight. Harold Rosenberg explained what he believed happened in his 1952 essay, "The American Action Painters": "At a certain moment the canvas began to appear to one American painter after another as an arena in which to act rather than as a space in which to reproduce, redesign, analyze, or 'express' an object, actual or imagined. What was to go on the canvas was not a picture but an event."

All the New York painters worked independently, but Matta, the youngest of the European Surrealists observed that they ". . . were all ready to explode. . . ." In much the same way, people throughout the world had reached a crisis point in the 1940s. With the explosion of the atomic bombs in Japan, the terrible loss of life in Europe and the Far East in World War II, the news that millions had been murdered by Hitler in concentration camps, the fear of the Soviet Union and the

Ad Reinhardt (1913–67) rejected Action Painting. He filled the canvas with large, pulsating areas of color as in this one called Abstract Painting, Red, *painted in oil on canvas in 1952.* ▼

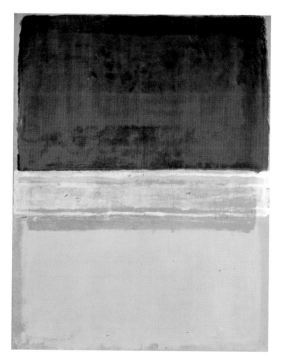

▲ Black, Pink and Yellow Over Orange *(1951–52)* *by Mark Rothko (1903–70) provokes an emotional response. "The people who weep before my pictures are having the same religious experience I had when I painted them," Rothko said.*

Lee Krasner (1908–84) painted Bird's Parasol *in oil on canvas in 1964. Her career was overshadowed by that of her husband, Jackson Pollock.* ▼

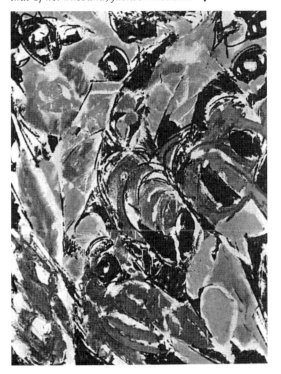

spread of Communism and the threat of a new war in Korea, most people were at a loss. All their values had been threatened and challenged in some of the darkest years in modern times.

American artists looked inward again during the crisis period after this war. From 1947 to 1953, many artists very abruptly began to make a new kind of art that was distinctively modern and American and which called to mind the vitality and toughness of New York. This art was an expression of the tension, violence and disorder they personally felt.

For Pollock and de Kooning the image ceased to matter in their art, although de Kooning sometimes introduced the human figure into his new work. The action in the application of the paint was what primarily concerned the Action Painters, as they were sometimes called. A painting was now the record of the artist's actions involved in putting the paint down on the canvas.

About 1950, the Abstract Expressionists divided into two groups with different interests. Jackson Pollock, Franz Kline, Philip Guston and William de Kooning continued working with the surface effects of the loose application of paint through physical gesture. The second group, the Color Field painters—Barnett Newman, Marc Rothko, Adolph Gottlieb and Ad Reinhardt—and, a little later, a second generation of painters—Helen Frankenthaler, Morris Louis, Kenneth Noland, Sam Francis and others—became interested in the dramatic impact of large areas of color. The work of Robert Motherwell and Clyfford Still remained somewhere between the two poles.

Although Abstract Expressionism represented a big breakthrough in art in America, these artists worked in isolation. Just as they began to find critical support and recognition from collectors and the public, their work began to lose its impact. Their contribution, however, made New York the new center of modern art. European artists now, for the first time, began to look to New York for new ideas.

Other Breakthroughs _____

Jackson Pollock, Willem de Kooning and others get a lot of credit for changing American painting so dramatically in the 1940s and 1950s. But there were many artists, just as isolated, creative and energetic, working at the same time with similar ideas. They received little recognition for their contributions. Among these artists are Giorgio Cavallon; his wife, Linda Lindeberg; Lee Krasner, Jackson Pollock's wife; Milton Resnick and others. They have begun to receive the recognition they are due, but unfortunately this has come after death. ■

12 Sculpture in America

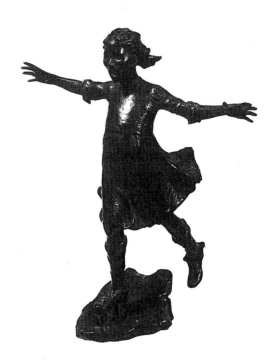

▲ *Abastenia St. Leger Eberle made figures in bronze such as* Roller Skating *(1909), representing characters she observed from her studio on the Lower East Side of Manhattan.*

For Gaston Lachaise, ▶ *the surface of the material in which he worked interested him as did rhythm of form and massive size. But while he made large forms he also sought to make his sculptures appear weightless. He was successful in achieving a feeling of weightlessness in this bronze figure,* Standing Woman, *1912–27, that stands seventy inches/over two meters in height.*

The development of sculpture in America in the twentieth century is a much less adventurous story than that of painting, for it was the last of the arts to mature. America had a long tradition of carving in wood and other materials. American Indians carved figures and totem poles and other objects. Ships' figureheads, cigar store Indians, scrimshaw carvings in whale bone and bird decoys for hunting were all traditional forms that American carving took. However, no modern, abstract, American sculptural tradition developed until about the 1940s, although there were some individuals who experimented earlier. In part this was because there was no real support and encouragement at the turn of the twentieth century from the National Academy of Design, or from anywhere else, to create a modern sculptural tradition. Any ideas about carving, casting metal, working in stone or other materials that the Academy recognized were based on European traditions in sculpture.

Some experimentation took place in American sculpture between 1900 and 1940. Elie Nadelman (1882–1946) was the first to produce abstract sculpture in America. He came to the U.S. from Poland in 1914. He produced witty, sophisticated figures in wood and other materials, experimenting with simple geometric forms, tapering, distorting and streamlining them. John B. Flannagan (1895–1942) was an interesting carver in wood and stone who produced romantic, mystical figures of animals and abstract forms in the 1930s, emphasizing the roundness of their shapes.

The first really important American sculptor was another immigrant, Gaston Lachaise (1882–1935). Born in Paris, he came to the U.S. in 1906 where he became one of the pioneers of modern American sculpture. He produced distorted earth goddess figures, intertwining couples and fertility symbol figures that he cast in bronze or carved in stone. Since his themes were charged with eroticism and dealt with unconventional subjects, his work was not easily accepted in America with its repressed sensibility in this period. In fact, Lachaise's work did not receive the recognition it deserved until the 1960s, many years after he had died. America had no outstanding living sculptor when Lachaise died in 1935.

The man who kept modernism alive in sculpture, as Stuart Davis had with painting after the Armory Show, was Alexander Calder (1898–1976). In the late 1920s he produced a circus scene made of wire that was full of fun and a sense of playfulness. After a visit in the 1930s to the studio of Dutch painter, Piet Mondrian, he was struck by

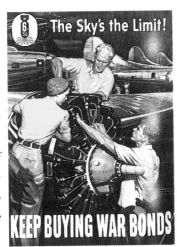

Women and ▶ other groups were recruited to work in U.S. defense factories during World War II. This is one of the posters produced to help boost the war effort.

Industrial America

Henry Ford (1863–1947) transformed the automobile industry in the early 1900s by introducing assembly-line production. During World War II assembly lines were put to work to produce tanks, trucks, jeeps, amphibious vehicles and other equipment needed to win the war against the Germans and Japanese. Production was enormous. For instance, in 1944 alone, a total of 96,000 airplanes or 260 per day, were produced in U.S. factories. Factories ran at capacity and the wartime economy finally solved the unemployment problems caused by the Depression. Industry had a new problem: finding enough workers to keep production figures up since most able-bodied American men had been drafted into the armed services. Many blacks found jobs in industry and received equal treatment from employers for the first time in their working lives, but racial resentment from fellow workers and other related issues were still problems faced by black workers. American industry had ideal employees in the women they hired as many were educated, energetic, enthusiastic workers, driven on by a sense of patriotism in their work. ■

the idea of "how fine if everything there moved." Calder became a pioneer of Kinetic Art, when he began to make mobiles from flat, painted, cut-out tin shapes and colored balls that he suspended from wire or cord. Some moved freely on their own while others were attached to motors that made them move.

In the late 1930s Calder experimented in making stabiles, cut from metal that became structures with fixed bases that did not move. Then he got the idea of suspending his mobiles from a fixed base. Calder's sculptures grew to gigantic size so that by the 1950s and 1960s some were monumental works, painted in Calder's signature fire-engine red and black. These elegant, giant forms needed to be seen in the environments for which they were conceived, some out-of-doors, to appreciate their full impact.

After World War II, sculptors took the wartime metal welding skills some had acquired in defense factories and applied these to their work. Welded metal sculpture of this period incorporated accidents, open forms, improvisation and surface effects that resembled no sculptural tradition before it. Iron and steel were materials with a sense of permanence that were easy to bend and cut and these were the materials with which most American sculptors experimented. These abstract metal sculptures were full of the fantasy and aggression found in post-World War II painting.

David Smith (1906–65), the descendant of a blacksmith from Decatur, Illinois, was the first American to work in welded metal.

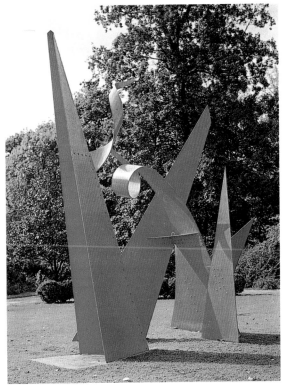

◀ The 100 Yard Dash *made in two freestanding, painted steel plate parts in 1969 by Alexander Calder is the kind of monumental work he produced until his death in 1978. Calder's sculptures are playful in their use of shapes. They often look like accidents that Calder put back into order.*

Experiments in Welded Metal

Experimentation in making metal sculpture began in abundance in America after World War II. Herbert Ferber (1906–) produced thorny, barbed images and tried to capture the energy of human gesture in metal. David Hare (1917–) began producing works in metal, about 1942, which were considered the sculptural equivalent of Abstract Expressionist painting. He also used surrealistic motifs in his work. Ibram Lassaw (1913–) produced works using metal grids and cage-like forms. Seymour Lipton (1903–) made dramatic organic forms in metal that resembled animal horns and human pelvic bones. Reuban Nakian (1897–) made heavy, dramatic, abstract works in metal that are full of tragedy. Theodore Roszak (1907–) used heavy metal shapes to produce violent organic forms. ∎

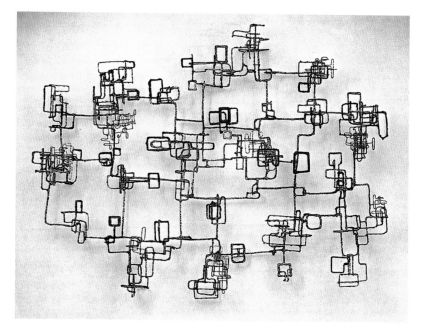

▲ *Ibram Lassaw's 1952 work,* Clouds of Magellan, *made in welded bronze and steel, shows the use of the grid design he often used.*

Many believe Smith was the greatest American sculptor of the twentieth century. He made his first welded iron sculpture in 1933 having acquired his iron-working skills in the summer of 1925 working in the Studebaker plant located in South Bend, Indiana. Smith went to New York in the late twenties and from 1926 to 1930 he studied painting at the Art Students' League. He thought of himself as a painter but after he borrowed welding tools to make his first abstract, welded metal sculpture in 1933, he worked almost entirely in metal. Smith's motivations were somewhat the same as the Abstract Expressionist painters in that he did not want to depend on European style and methods when making his sculpture.

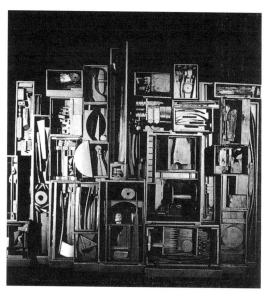

▲ *Louise Nevelson's wall construction,* Sky Cathedral—Moon Garden + One, *is made entirely of wood and painted black. It measures slightly more than 9 by 10 feet/2.7 by 3 meters and is typical of the work for which Nevelson was best known.*

Sculpture in Other Materials

American sculptors experimented after World War II with other traditional materials like stone and wood. Isamu Noguchi (1904–88) made abstract sculptures using forms found in nature as an inspiration. He produced elegant works in wood and stone. Raoul Hague (1904–) used his direct carving skills to make robust abstract forms in wood. Gabriel Kohn (1910–) used his shipbuilding skills to make graceful pieces in wood, full of tension and drama. Wooden slats, balustrades, finials and chair legs can all be found in Louise Nevelson's (1899–1988) constructions painted all one color. ∎

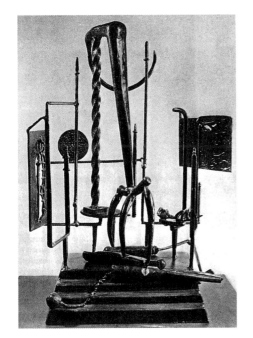

▲ *David Smith achieved a rhythmic lightness using a heavy material. This is* Cathedral *made of painted steel in 1950.*

David Smith's work became monumental in size in the 50s and 60s. This work is called Cubi XIX *made of stainless steel in 1964. It is almost ten feet/three meters tall.* ▼

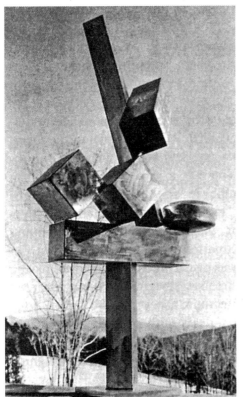

Smith described himself as "a sculptor who painted his images" and indeed many of his sculptures were designed to be seen best from the front—just like paintings. Silhouettes and planes were also important in Smith's work. He always preferred to work in iron or steel—industrial age materials—because he said this material "possesses little art history. What associations it possesses are those of this century: power, structure, movement, progress, suspension, destruction, brutality." Smith, who died in 1965, was to be the last of the welded metal sculptors in the twentieth century whose work had an impact on young artists throughout the world.

▲ *Joseph Cornell (1903–73) produced small pieces combining all kinds of materials that he generally assembled in boxes. This one, entitled* Sun Box *(approx. 1955) is made from cork, metal and painted wood. Cornell chose materials for his assemblages that were full of all sorts of associations. In most cases, the meanings of these works were known only to Cornell.*

Sculpture After the 1950s _____

Modern American sculpture burst forth and took many forms in the twentieth century. Joseph Cornell, H. C. Westerman and Edward Kienholz made assemblages combining unlikely images and objects. Lee Bontecou, John Chamberlain, Richard Stankiewicz and others made sculpture from junk and found objects. Some worked with industrial materials like Ronald Bladen, Larry Bell, Donald Judd, Robert Morris and many others. Eventually American sculpture ceased to take traditional forms and volumes, when Environmental, Minimal, Conceptual, Video and Computor artists changed sculpture in the second half of the twentieth century. ■

13 The Art of Popular Culture, 1955–63

Willem de Kooning said Jackson Pollock "broke the ice" for American art. He was right, for a flood of activity characterized the art scene in New York from the mid-1950s onward. No single style dominated, nor probably would again, as artists experimented with and embraced every medium—painting, sculpture, collage, silkscreen, lithography, theater, dance, video and photography. Artists began to use every image, material and object to make art. Post-Abstract Expressionist artists seemed to be inspired by the words of Marcel Duchamp who said that art was not as important as life; and if it was any good, art should be a piece of life itself. A handful of young artists began in the mid-1950s to incorporate into their work a slice of life in the form of everyday objects.

The bridge from Abstract Expressionism to what the British art critic, Lawrence Alloway, first called "Pop Art" in 1954, was made by two young New York artists, Robert Rauschenberg (1925–) and Jasper Johns (1930–). In the mid-fifties Rauschenberg painted in a loose, painterly style, much like that of the Action Painters. He began to add bits of cloth and newspaper, images from magazines, comic strips and discarded items

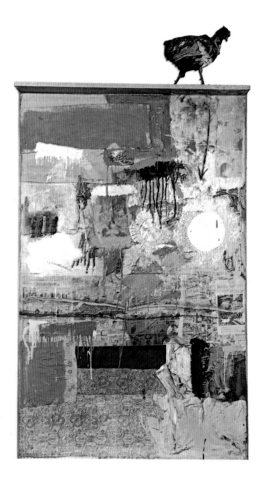

◀ Satellite *(1953–55)* *was one of Robert Rauschenberg's first attempts to introduce junk or found objects in his paintings. Paper doilies, old bits of cloth, newspaper comics and a stuffed pheasant missing its tail feathers were all combined with the paint Rauschenberg applied. He had a great curiosity about what a painting actually was or was not and tried out everything. He used everyday objects in his work, forcing people to think about the relationship of art to reality.*

▲ *Cars served as status symbols in suburbia and made life there possible for Americans who needed to commute to work in nearby cities.*

Growth of a Consumer Culture ___

Times were good in America after World War II. People had more leisure time and money to spend in the 1950s. Birth rates increased dramatically in the 40s and a "baby boom" continued into the 1960s creating a demand for consumer goods and housing. Housing developments grew and more highways were built as people moved out of the cities to raise their families in the suburbs. The car made the move possible. The middle class grew and generated more consumption. Nearly everyone, it seemed, aspired to the middle-class lifestyle and wanted to be like everyone else. Americans spent billions "keeping up with the Joneses". Prosperity meant that fewer Americans experienced serious need. Personal comfort, pleasure and amusement began to be the goal of American life and it often seemed empty resulting in boredom and purposelessness. ■

intentionally to his paintings or "combines", as he called them. This took Pollock's accidental incorporation of discarded junk in a painting one step further. Rauschenberg described what he was up to as "a collaboration with materials." "Painting," he said, "relates to both art and life. Neither can be made. (I try to act in the gap between the two)." His paintings became large combines to which he added big objects like ladders, chairs, tires, quilts, and even a stuffed goat. Rauschenberg was reproducing in these works the lack of order he saw around him. "I don't want a picture to look like something it isn't," he said. "I want it to look like something it is. And I think a picture is more like the real world when it's made out of the real world."

There is something matter-of-fact about

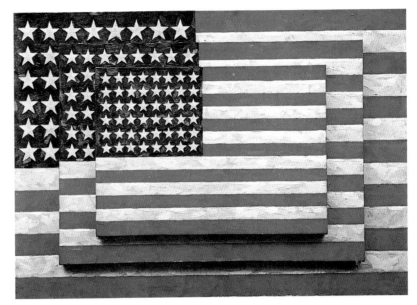

▲ Three Flags, *1958, is one of the dozens of flag paintings Jasper Johns produced using encaustic on canvas, a process in which pigment or other materials are mixed with hot wax and affixed to the canvas surface.*

▲ *Robert Rauschenberg was interested in the relation of paint and real objects and, like the Abstract Expressionists, the overall composition. He incorporated a stuffed, horned, long-haired Angora goat into* Monogram (1959). *The goat was probably the largest object he had ever tried to incorporate into a combine. He struggled five years to make the goat look as if it belonged in the painting. After producing two other versions, a suggestion from Jasper Johns gave him the solution. Rauschenberg placed the goat on top of a collage laid on the floor. One critic said Rauschenberg created for the goat ". . . an environment, a place for him to be, a pasture."*

Inspired by the American Dream__

Pop Art used the images, techniques, language and style of commercial illustration and advertising with great sophistication. Popular culture and the "American Dream" supplied the artists with material and subject matter. Andy Warhol (1928–87) used commercial packaging and multiple images of objects and famous people as subject matter and often, the silk screen process of commercial and industrial printers. Roy Lichtenstein (1923–) blew up comic strips and cartoons to a large size. Claes Oldenburg (1929–) made huge, tactile soft sculptures of hamburgers, telephones and typewriters. Robert Indiana (1928–) painted giant, menacing signs and badges in brilliant colors. James Rosenquist (1933–) airbrushed paintings used giant advertising fragments and images from billboards. ■

Children born ▶ *between 1940 and 1950 were the first generation to grow up with television and other consumer goods their parents and grandparents never even dreamed could exist.*

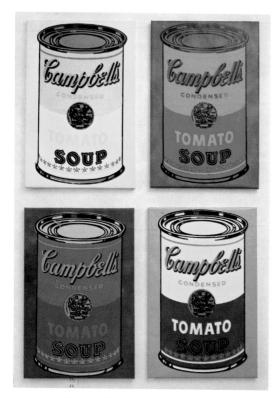

▲ *Andy Warhol eliminated the notion that art had to be made by hand. He used stencils and the silk screen process to make multiple paintings, each one looking more or less the same. These silk-screens, entitled* Four Campbell's Soup Cans, *were produced in oil on canvas in 1965. Andy Warhol paid assistants to mass produce his paintings and other works.*

Claes Oldenburg is shown here with four of his soft sculptures. He stands behind Floor–Burger, *produced in 1962, from painted canvas stuffed with foam.* ▼

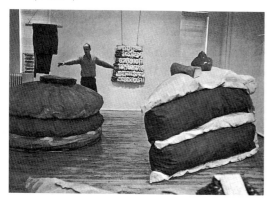

Rauschenberg's combines. Neither the paint nor the objects are given a special focus—both are given equal treatment. The viewer sometimes feels that the objects were always meant to end up in the place in which Rauschenberg put them in his work. Objects were included to provide a place for the eye to stop in the flow of paint. He challenged the idea that art is something separate from life by combining paint and real-life objects on the surface of a painting.

Jasper Johns worked with the idea of painted illusion. Johns painted ". . . things that are seen, but not looked at in ordinary life," he said. About 1954, he started painting familiar objects such as American flags and targets—objects so familiar that people don't really look at them, because the mind already knows the design. By paying careful attention to the surface texture in applying paint, Johns almost convinces the viewer that he has painted a replica of a flag, for instance—a "thing" that hangs on the wall—instead of a picture of one. The paint has been applied so that the brushwork cannot be detected and seems to become part of the object. Johns challenges the viewer to look at what is seen and question what it is. He makes the viewer think about how the brain decides what it is that is actually being looked at.

Rauschenberg's and Johns's work inspired a young group of artists, all working independently. Their new work exploded on the art scene with great energy. The Pop artists—Andy Warhol, George Segal, Jim Dine, Marisol, Robert Indiana, Roy Lichtenstein, Tom Wesselman, James Rosenquist, Claes Oldenburg, Billy Al Bengston, Joe Goode, Mel Ramos, Edward Ruscha, Wayne Thiebaud and others—used images and objects from popular, mass culture. This group of artists threw aside the emotional content of painting, the painterliness of Abstract Expressionism and previous styles and replaced them with the coolness and slickness of commercial art, advertising, commercial

Pop Art's Success _____

Pop Art, inspired by familiar, popular images, was easy for the general public to understand. Its appeal may explain why this art sold well. Success and fame came to the young Pop artists quickly. Andy Warhol's theatricality and success made him an international celebrity. Robert Rauschenberg achieved international fame after he became the first American artist to win the top prize at the *Biennale* exhibition in Venice, Italy in 1964. Success and power came to art dealers in the 1960s and the most influential were Leo Castelli, André Emmerich, Ivan Karp, Betty Parsons and Ileana Sonnabend. Gallery owners were keen to establish the reputations of their artists internationally. American art had become big business. ■

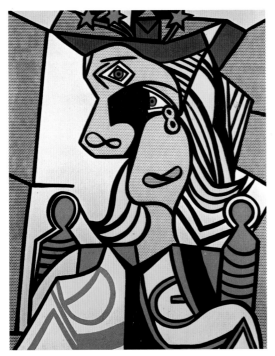

▲ *Roy Lichtenstein blew up comic strips to a large size and in this case transformed the main character into a* Woman with Flowered Hat *(1963) that he painted in oil on canvas in the Cubist style.*

Youth Culture

In 1961 John F. Kennedy (1917–63) became the youngest man at age forty-three to serve as president of the United States and the first president to be born in the twentieth century. President Kennedy, his young wife and family seemed to set an optimistic tone for the country in the 60s. Kennedy's tongue-in-cheek wit, openness, irreverent humor, skepticism and coolness were ever-present. Adlai Stevenson (1900–65), U.S. ambassador to the United Nations 1961–65, called him "the contemporary man." The stagnation of life in the 50s under the administration of President Dwight D. Eisenhower (1890–1969) contrasted dramatically with the dynamic Kennedy years. Life was easier for young people in the 60s than it had been for their parents and grandparents. Older Americans were baffled and frightened by the 1960s youth culture and the great changes it brought to American life. The success of rock-and-roll music, the use of the birth control pill, widespread use of drugs, the civil rights movement, anti-Vietnam war protests, black power, radical feminism and more were all driven by the energy of young Americans beginning in the 1960s. ■

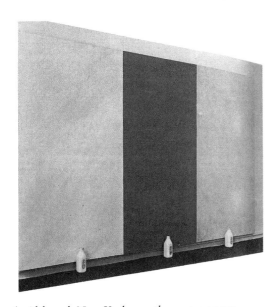

▲ *Although New York was the center, many California artists also produced Pop Art. Joe Goode included common household objects in his works such as this one called* Leroy, *produced in 1962. He leaned painted milk bottles against a huge field of color painted in oil on canvas.*

packaging, television and the movies.

Pop Art was a means of coming to grips with the excesses and vulgarity of urban and suburban life in the fifties and sixties. Although it spread to Canada and Europe, the style, born in the U.S., had an American coolness and an absence of commitment to or detachment from its subject matter. It was impersonal and avoided the "particular" like all abstract art. It was also a very American expression in the way it held a mirror up to society and boldly exposed the content of commercial or pop culture. It commented on society. It attacked materialism, the spiritual emptiness of modern life, the way the mass media had introduced a sexual element into the environment and turned masterpieces and traditional values into clichés. At the same time however, it embraced all these things it challenged. It was also humorous and very entertaining because it was full of information.

This lively, colorful, impersonal and unsentimental art had a great impact. It burst on the art scene unexpectedly and was looked at by some as a victory over, or relief from, the serious, introverted, emotionally loaded art of the Abstract Expressionists, that lacked an appealing pictorial content to which "the man on the street" could relate. Pop Art was a visual art for the masses and more like an event than an art movement. It was like an exaggerated extension of the popular lifestyle. Duchamp would surely have approved, for this art movement was a slice of real life.

45

14 The New Realism

Pop Art disappeared as quickly as it burst on the scene and after the mid-60s little art grew from the Pop tradition in America. However, the work of the Photo-Realists, in the mid- to late 60s, did take its candid and unsettling honesty from Pop Art. This group of *tromp l'oeil* artists, mostly painters, based their work on contemporary scenes and characters rendered in a detailed, super-realistic, hard-edged style from photos and commercial advertising images. Although this work makes the viewer wonder how an artist could paint in such microscopic, almost photographic detail, the paintings are cold and lifeless works of art lacking the irony and elements of fantasy and fun that made Pop Art so appealing. While Pop artists held a mirror up to the modern world, the Photo-Realists examined it under the microscope. Their paintings make the viewer feel uneasy. They distort the way we view the world by blowing it up in great detail and taking a very close look. The images are full of tension because their startling detail is pushed to an extreme.

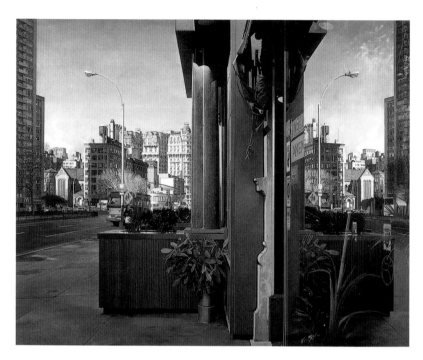

▲ *Richard Estes painted this New York scene entitled* Ansonia *in oil in 1977 from photographs. There is no nostalgia in the dull realism Estes paints.*

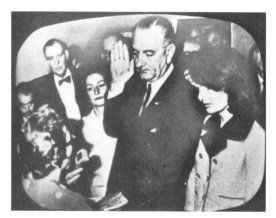

▲ *As a shocked nation watched on televison, Lyndon B. Johnson took the presidential oath of office on board Air Force I on November 22, 1963, after President Kennedy was assassinated earlier that day.*

Watching the News in the 60s_____

People were inspired in the early 60s by their new young president, John F. Kennedy, who seemed to refuse to be conned and showed grace under pressure. This was most evident when the Berlin Wall went up in 1961 and during the Cuban Missile Crisis in 1962. After Kennedy's assassination in November 1963 and other unsettling events, high spirits turned to rage and frustration. Watching the news on television became an ordeal. Police violence, race riots, student protests, Vietnam War body counts and more assassinations of public figures were all broadcast live into every American home. This close contact to world troubles made many people despair, some to demonstrate and others to join the riots. One Detroit rioter told a journalist, "The rebellion was all caused by the commercials. I mean you saw all those things you'd never be able to get . . . just hanging out there." Lyndon B. Johnson's (1908–73) presidential term (1968–69) with its policies and problems inherited from the Kennedy administration, seemed to split the nation. ∎

Television, which thrust the assassination of President John F. Kennedy; the mourning of his family and the nation; then the assassinations of the civil rights leader Martin Luther King and the presidential hopeful, Robert Kennedy (1925–68); the riots that first exploded on the streets of America in 1964; the Vietnam War; the resulting peace demonstrations and police violence into every American home, is a more likely inspiration for this body of work. All the violent, distressing and frightening events left many Americans troubled, hopeless and depressed. The work of the Photo-Realists manages to produce a similar, uneasy viewer response.

Philip Pearlstein's (1924–) nudes, for instance, are harsh representations of figures,

◄ Chuck Close's close-up portraits look as if they were painted from a position that was so close that a camera must have been stuck right in the sitter's face. Close actually makes his paintings by magnifying and projecting photos of his subjects onto the canvas. This is the artist's 1968 self-portrait, painted in acrylic on canvas.

▲ Scenes like this one of civil rights supporters being forced to move on by Alabama firemen in 1963, were what Americans in the 60s and early 70s came to expect to see on television every night.

in domestic settings and deliberately ugly in their explicit sexuality. John Clem Clarke posed his nudes in reenactments of mythical scenes, a commentary on the new "sexual freedom" of the 60s. Alfred Leslie painted monumental portraits, overwhelming the viewer in their size and detail, while Chuck Close's (1940–) portraits are magnified images where all the imperfections of the sitter are recorded. Close's portraits lose recognizability because the perspective is so close, almost like a television camera lens stuck right into someone's face.

Duane Hanson

Photo-Realism fell out of fashion very quickly, but there was one Photo-Realist whose work captured the affection of an international public and remained popular throughout the century. Duane Hanson (1925–96) made the first of his replicas of ordinary people, cast from life and dressed in real clothing in 1967. Hanson tried to document contemporary life. His figures are so lifelike that they look like living, breathing people. Hanson bluntly represented the hard facts of American life during the terrible years in America from 1963 to the early 70s. He often represented scenes of people out of control. His characters are overweight, violent or drunk, but the reaction to them is often a mixture of wonder, shock and even affection. Hanson continued to make his sculptures until his death in 1996. ■

◄ Duane Hanson's Photo-Realist sculptures are so lifelike they look like they are breathing. This is Hanson's Self-Portrait with Model, made from polyvinyl acetate in 1979.

15 Anti-Expressionist Art

▲ *Using a few movements, Yvonne Rainer (right) performs* The Mind Is a Muscle, Trio A *in 1966.*

▲ *Minimal artists used industrial materials. Carl Andre's (1935–) 1966 work entitled* Lever *is made from bricks lined up on the gallery floor.*

American Art in the late sixties and seventies took yet another dramatic turn. Reacting against the personal, emotional content of Abstract Expressionist art and the flamboyance of Pop Art, American artists took their art down to the extreme basics, to stress the literal qualities in a work of art. Basic qualities such as color, shape and flatness, took on new importance. No gestural traces, no accidents, no symbolism, illusion or realism were a part of this art. It was an art concerned with order and concept only. Through this work, American artists also began to erase the gap between painting and sculpture as the two media began to merge.

First called Minimal Art in the late sixties, this was an art of reduction and renunciation using simple geometric shapes such as cubes and rectangles, non-conventionally shaped canvases and ready-made industrial materials such as cement blocks, brick, styrofoam, plastic and pieces of wood and metal. Some artists painted in bright industrial colors. Other works were simply black, white or colorless. One artist said these plain and ugly works of art, reflected the American "taste for the miserable" and a critic said it was "an art on the verge of exhaustion." The industrial and not the man-made look was what was important. On the surface this was a severe, repetitive and boring art. Most people found it unappealing or simply could not understand it at all. The critic Barbara Rose explained the problem with this art

Art of Boredom

The "art of boredom" took many forms in the late sixties and seventies. La Monte Young produced "trance music" that supposedly had a hypnotic affect in its monotony. John Cage's (1912-) music could consist of silence or one or two simple sounds repeated over and over again. He also wrote music for percussion instruments only. Modern dance also got down to basics as choreographers and dancers, such as Merce Cunningham, Yvonne Rainer and Trisha Brown created complete dance pieces based on only a few movements of the body repeated throughout the performance. Andy Warhol's underground films focused on the mundane lives of his bizarre characters. The films were filled with the boredom and repetition of everyday life. These films had no real plot and little action and at the end the viewer realized that nothing much had happened. This music, dance, film and the art produced by Minimal artists really tested the commitment of the audience. ■

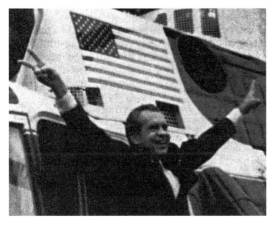

▲ President Nixon bade farewell to the nation on the lawn of the White House after he resigned office rather than face an impeachment and possible removal from office. Gerald Ford (1913–) became America's first non-elected president from 1974 to 1977. His first official act was to pardon Nixon.

On May 4, 1970, in response to rocks and bottles being thrown by Kent State University students protesting the Vietnam War, Ohio National Guardsmen responded with tear gas and when it ran out, they began to shoot. Four students were killed and eleven wounded. In 1974, eight guardsmen were indicted and then acquitted on criminal charges of violating the civil rights of the students. ▼

was that the ". . . art content of such works. . . is intentionally low, and . . . resistance to this kind of art comes mainly from the spectator's sense that the artist has not worked hard enough or put enough effort into his work."

Minimal art perhaps reflected the boredom, hopelessness and loss of faith in America on the part of many citizens that characterized the years of President Richard Nixon's (1913–1994) term of office from 1969 to 1974. These were the years in America when despair and fear characterized the mood across the country. Some say this art also reflects the attitude of the sixties drug culture. Its self-proclaimed leader, Timothy Leary (1920–96), whom Richard Nixon described as "the most dangerous man in the world," advised the world to "turn on, tune in and drop out."

What were these artists up to? The artist Frank Stella (1936-) seemed to sum it all up in a radio interview he gave in 1964: "I always get into arguments with people who want to retain the old

The Nixon Years

Richard Nixon's years in the White House were full of turmoil. After the enormous and rapid changes of the sixties, Americans were left feeling disoriented. The 1960s were so turbulent that people seemed to have reached a saturation point during the years of Nixon's presidency. It was almost as if the American people could take in no more bad news. There was more to come, however. The 1970s began with the killing of four Kent State University students by Ohio National Guardsmen during an anti-Vietnam War rally. Nationwide protests followed. The Vietnam War had created so much stress in the country that people became more and more divided in opinion as to whether American involvement and loss of American lives in Vietnam, a country thousands of miles away, should be a U.S. problem at all. Nixon wound down American participation in the war and called for peace without having won a victory, after more than 50,000 American lives had been lost. High inflation, a recession and an embargo on oil exports to the U.S. from Middle Eastern suppliers threw the economy into turmoil. In 1973 Vice President Spiro Agnew had to resign because of corruption charges and Gerald Ford was appointed vice president. The dirty tricks campaign run by Nixon aides during the months leading up to the 1972 presidential election, culminated in what became known as the Watergate affair, which eventually led to the resignation of President Nixon on August 9, 1974. The nation was left numb from the Vietnam war, the troubled economy and from this scandal with its source in the office of the head of state. ■

Morris Louis's ▶ *painting style changed after a visit to Helen Frankenthaler's studio. In 1954, he began to pour watered-down acrylic paint onto raw canvas and managed to create paintings like* Nun *of 1959. His work and Frankenthaler's had a significant impact on the work of Minimal artists. Barbara Rose said that Louis's huge paintings made from areas of pure color looked "like natural phenomena emerging from a mist."*

Roots

Minimal Art could trace its roots to the monochromatic paintings of Mark Rothko, Ad Reinhardt and Barnett Newman, the Abstract Expressionists who began in the fifties to concentrate on the expressive power of large areas of pure color. The work of a second generation of painters, consisting of Helen Frankenthaler, Morris Louis, Kenneth Noland, Sam Francis and several others, also inspired the work of the Minimal artists. Louis (1913–62) and Frankenthaler (1928–) applied paint in flat stains of color without any texture. This particularly interested Minimal artists. Josef Albers's experimental series begun in 1950 called Homage to the Square that focused on the way areas of color interacted and changed when placed in close relation, was work Minimal artists looked at in their attempt to get down to the basics in their own work. ■

values in painting—the humanistic values that they always find on the canvas. . . . they always end up asserting that there is something there besides the paint on canvas. My painting is based on the fact that only what can be seen there *is* there. . . . All I want anyone to get out of my paintings, and all I ever get out of them, is the fact that you can see the whole idea without any confusion. . . . What you see is what you see." The thinking behind this art, was different from the ideas that produced the art made since the end of World War II in that the approach was that "art derives from art and *not* life" as Barbara Rose wrote.

Minimal Art is a complex style, for by *not* doing something, an artist can also make a positive statement. Lots of issues such as nega-

Helen ▶ *Frankenthaler's work inspired the work of Minimal artists. This is* Mountains and Sea *which she painted in 1952 using thin washes and stains of paint.*

The viewer takes an ▶ active role in Larry Poons's (1937–) paintings, like this one called Han-San Cadence, 1963, painted in acrylic and fabric dye on canvas. Poons's contrasting color combinations make the shapes he paints vibrate and create afterimages

▲ Frank Stella (1936–) cut a hole in the center of this oil on shaped canvas entitled Ileana Sonnabend, 1963 to draw attention to the flatness of paint on the surface of the canvas.

Sol LeWitt's (1928–) untitled work of 1966 is a three-dimensional painted aluminium grid. ▼

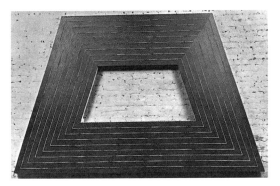

tive space; the power of nature and mechanical things; the influence of architectural elements on a work of art, such as walls of art galleries or placement on the walls and floor were explored by Minimal artists. Color as shape, the illusion and theatricality of art works and the lack of these and many other things were examined in carefully thought-out works. The audience viewing the work also became important. Minimal artists paid special attention to where their works were shown and how they were viewed. Minimal artists attempted to challenge the observers' minds by introducing lots of changes in the methods used to make art and in the reasons for making it.

Abstract Expressionist painters emphasized the personal involvement of the artist in making art, for their paintings were the record of the artists' actions. Minimal artists took attention away from the artists and knocked away the high pedestal on which art, painting, sculpture and the artist had traditionally been placed. They rejected the glorification of handywork. Minimal artists recognized that these ideas, which they considered old-fashioned, kept some people from looking at art, for the old ideas set up a barrier some viewers would never cross.

Minimal Art Theory _____

Minimal artists were interested in making clear the thinking behind what they were doing. They actively sought the support and cooperation of their critics to help explain what their art was all about. Many artists wrote art criticism themselves. The critic, Harold Rosenberg joked: ". . .the rule applied is: the less there is to see, the more there is to say." ■

16 Conceptual Art

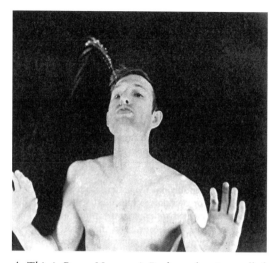

▲ *This is Bruce Nauman's Bodyworks piece called* Self-Portrait as a Fountain. *The artist became the work of art in this performance of 1966. Nauman often is a solo performer in his pieces that were generally not performed live but filmed or videotaped for presentation. He seems indifferent to his audience in these films or Activities, as one critic called them, as if the audience simply does not matter at all.*

As the 1970s progressed art was no longer thought of only as paint applied to canvas or a monumental, free-standing form. Art became the idea, not its representation in form, a real process that took place in real time, a performance, an action. The critic Lucy Lippard wrote that "dust, literature, accident, nature, scientific illustration, theater, dance, or pedagogy theory," could all be thought of as art in the 1970s. Hundreds of unconnected artists worked in every conceivable way with Bodyworks (with the emphasis on body movement), dance, performance and on monumental Environmental Art projects. Most, however, showed or performed in art galleries. The environmental artist Robert Smithson (1938–73) said: "Painting, sculpture, and architecture are finished, but the art habit continues."

Artists React

Most artists during the troubled seventies, never left their studios or the environment of the hundreds of art galleries that had opened across America, to get involved as artists in the world outside. By contrast, other groups of people with common interests were organizing and protesting about the rights of women, homosexuals and minorities, the Vietnam War and unjust government policies. As a group, American artists hardly responded to the troubles. A few artists made art in reaction to the 1968 Democratic National Convention police riots, but except for the Art Workers Coalition, formed in 1969 to demonstrate against the Vietnam War, little organized protest took place in the art world. Robert Rauschenberg's philosophy was, "I don't march in parades. But I think I relate more to society than any idea about art history. I feel the world is here to do something about and with." This may be what other artists thought or perhaps it was just apathy, that prevented artists from getting involved more actively. ■

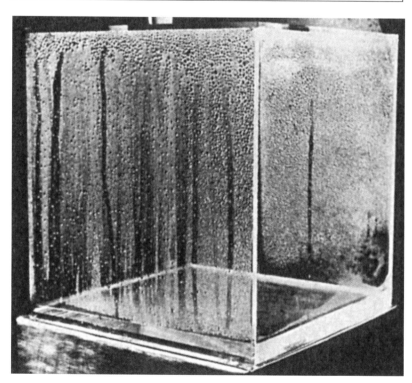

▲ *Hans Haacke (1936–) is interested in the way things react to their environment.* Condensation Cube *(1963–65) is made from clear plastic. The water locked inside changes with the temperature.*

The earth artists, in particular, seemed to form ". . . an intense antagonism to the commodity aspect of art," the writer Calvin Tomkins reported, particularly in the form of the New York art dealer and gallery. They intentionally made very large works of art in landscapes that were mainly located in remote, out-of-the-way places. Only the documentation of the work they did—photos, written reports, films, video—could be displayed and sold as works of art. The documents, however, never revealed the full impact of these Earthworks, as they were called.

The critic Harold Rosenberg called all the art of this period "post-studio art". He said, "The uncollectible art object serves as an advertisement for the showman-artist, whose processes are indeed more interesting than his product and who markets his signature appended to commonplace relics. To be truly distinctive of the aesthetic, art *povera* (another word for Earthworks) would have to forsake art action for political action."

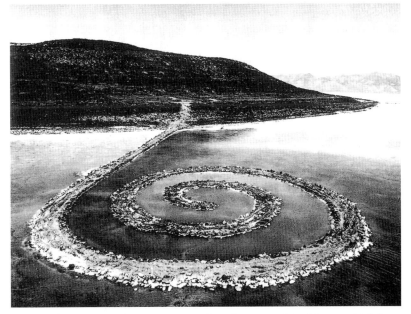

▲ *This is Robert Smithson's giant Earthwork project,* Spiral Jetty, *which he engineered in the Great Salt Lake in Utah using mud, salt crystals, rocks, water and algae imprinted in a giant spiral onto the landscape. Because of its great size (fifteen feet/four and a half meters wide) it was best viewed from a plane or through photo documents like this one.*

Solzhenitsyn

The GULAG Archipelago

An Experiment in Literary Investigation

For years I have with reluctant heart withheld from publication this already completed book: my obligation to those still living outweighed my obligation to the dead. But now that State Security has seized the book anyway, I have no alternative but to publish it immediately.

THE AUTHOR

Change in Attitude

Many artists applied for government grants during this period made possible by the formation of the National Endowment for the Arts and Humanities in 1965, one of the many projects to receive funding under President Lyndon Johnson's administration. Other artists found teaching positions. In the seventies artists as a group seemed for the first time to be reaping the benefits from the change in heart in America, that art and artists were indeed valuable and important members of society and could contribute something to the education of America's young people. The Cold War attitude also persisted that art could be a valuable weapon to fight Communism, for in Communist countries, outspoken artists, writers, poets, dancers, and musicians were punished if their art criticized the system and if their art could potentially communicate this message of disatisfaction to a wider public. ■

◄ *The simultaneous publication in the United States and Great Britain of Aleksandr Solzhenitsyn's (1918–)* The Gulag Archipelago *in 1973, is an example of the way art could be used as a Cold War tool to defy the Russian attempt to silence this author. The book describes the history of repression in the former Soviet Union.*

17 Art Embraces Technology

Television Facts

In 1925 the Scottish inventor John Logie Baird transmitted the first recognizable human features by television. The first scheduled television broadcasts were made by station WGY in Schenectady, New York in 1928. In New York in 1938 20,000 television sets were in service. By 1951, 15 million total sets were sold in this country and the first color sets began to be available. It was estimated in 1970 that consumers owned about 231 million sets worldwide. In the 1990s the figure in the U.S. was about 100 million. ■

Nam June Paik was one of the first video artists in America. This 1982 installation is called V–yramid *is made from forty televisions.* ▼

When some American artists stopped using nature as their model and art began to be involved with information in the late sixties, it was inevitable that American art would begin to make use of technology. Post-World War II America saw great advances in technology. Computers, the microchip, television, laser, sophisticated light and sound recording techniques were twentieth-century landmarks in technology, once only available for use by professionals because of their prohibitive costs. From the 1970s through the 1990s various forms of the latest technology were made available to the consumer through research and mass production. The personal computer, color and cable television, the large television screen, the compact disc and player, fax machines, electronic mail, home video systems, the portable video camera and more could be easily acquired at reasonable prices.

Once American artists began to work with technology all kinds of experiments began to take place. Earthworks projects began to be documented by artists using photography, video, computers, sound recording and other technology. Environmental artists and others such as Vito Acconci, Eleanor Antin, John Baldessari, Judith Barry, Lynda Benglis, Allan Kaprow, Les Levine, Mary Lucier, Robert Morris, Bruce Nauman, Dennis Oppenheim, Nam June Paik, Richard Serra, Keith Sonnier, Bill Viola, William Wegman and many others began to experiment with the medium of video. Human psychological dramas, parodies of commercial television and television environments were the forms these videos took. All video art has a spontaneity, full of accidents and imperfections and is involved with a sense of the movement and passing of time. Video art went in and out

▲ *The U.S. won the Cold War race to the moon when in July 1969, Neil Armstrong (1930–) took the first step on the moon. Edwin E. "Buzz" Aldrin, (1930–) is shown with the first U.S. flag raised on lunar soil.*

Technology Power

The technology a country possesses has always been important in determining its political power in the world. In World War II the race to develop the first nuclear weapons was won by the United States when its atomic bombs destroyed Japanese cities in 1945. This marked the start of the Cold War arms race between the U.S. and the former Soviet Union. To get the first man in space and then on the moon were the next Cold War power struggles. The development of high-powered computers, smaller and increasingly sophisticated computer components and software became a way to achieve economic success in the eighties and nineties. The development of communication satellites that relay telephone calls, fax communication, computer E-mail and television pictures around the world raised the question of who should pay for and control the use of the satellites. Organizations such as Intelsat, were formed to regulate the international use of satellites. ■

of fashion after the big burst of activity in the late sixties and seventies. In the 90s, when very sophisticated T.V. equipment became available to artists, there was a revival.

Other artists like Stephen Antonakos, Chryssa, Dan Flavin, Len Lye, George Rickey and Weng-Ying T'sa'i used light, neon and motion, or a combination of these, to make sculpture. James Seawright made sculptures, he said, ". . . that happened to be a machine." They have moving parts and the movement is brought about by changes in the environment. Artists created environments using multimedia technology to overwhelm the senses of sight, sound, touch and smell. Artists, for the first time, collaborated with corporations such as Pepsi Cola and Bell Technology, to name but a few. These made funding, staff, equipment and facilities available to artists and sponsored expensive projects involving every phase of technology. In the 1990s art began to be made and sold in on-line galleries on the Internet through companies such as Art Net and Art in Cyberspace.

At the center of all this activity was a revolution in technology, mass media and communication. A new information environment was created in the eighties and nineties. Control of information and the media became a means to gain political power and accelerated the tempo of world events and public opinion. The German-born artist, Hans Haacke, best described the changing role of artists in relation to the world around them when he said: "The artist's business requires his involvement in practically everything. . . . It would be bypassing the issue to say that the artist's business is how to work with this and that material and manipulate the findings of perceptual psychology, and that the rest should be left to other professions. . . . The total scope of information he receives day after day is of concern. An artist is not an isolated system. In order to survive. . . he has to continuously interact with the world around him. Theoretically, there are no limits to his involvement." As technology continues to develop and the world changes in the twenty-first century it is exciting to imagine just what American art will be like.

The Pulsa Group ▶ *used computers to change light, sound and heat in relation to weather, flow of traffic or presence of people in* Yale Golf Course Work *in New Haven, Connecticut in 1969.*

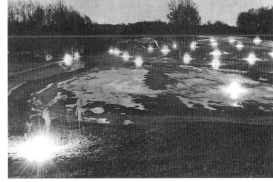

18 Neo-Expressionist Art of the Eighties and Nineties

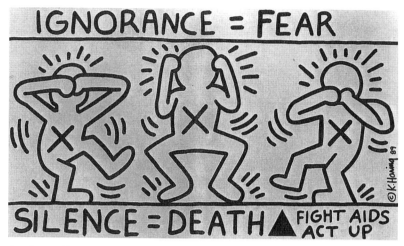

▲ *The graffiti artist, Keith Haring (1958–90), created posters to help AIDS organizations raise money. He designed this one in ink on paper, called* Ignorance = Fear, *in 1989 for ACT UP. Haring died of AIDS in 1990.*

My name is Linda Nishio. I am 28 years old. I am a third generation (sansei) Japanese/American. I grew up in L.A. in a household where very little Japanese

was spoken, except of course by my grandmother, who spoke very little English. during those early years I picked up some Japanese phrases, a few of which

I still remember today. Then I went to Art School on the East coast. I attended classes in an environment where very little art was taught but where iconoclastic

rhetoric (intellectualism) replaced "normal" art education. Before long I realized I, too, was communicating more and more in this fashion. Ho hum. Upon return-

ing to L.A. I found myself misunderstood by family and friends. So this is the story: A young artist of Japanese descent from Los Angeles who doesn't talk normal.

KI·KO·E·MA·SU KA
(Can you hear me?)

Life and art in America came closer together than ever before in the 1980s and 1990s. Both had become politicized and much art began to focus on social and political ideas. Art became a means for artists to search for their identities in a time when not only artists, but most Americans, were beginning to have grave doubts about the state of the world in which they lived. Large crises that affected the world—the AIDS epidemic; mass starvation in Africa; natural disasters; the fragile state of the environment and the threats to many endangered species of wildlife; wars in the Middle East, Africa, the former Yugoslavia and Soviet Union; racism and human rights violations on a mass scale throughout the world; a worldwide recession bordering on another Depression; massive job cuts; and an ineffectual U.S. government and other issues made many people wonder what the future held for them and what control they had of their own lives. Americans were full of misgivings and disappointment.

This was a period when Americans and American artists began to really question and reject the past. Television and the media played a

◄ *Linda Nishio is a Japanese-American whose work often deals with the problems of alienation and assimilation through the use of languages. In this photographic work, entitled* Kikoemasu Ka (Can You Hear Me?), *the artist, who appears in the work, calls out to be seen and heard.*

large part in the thinking and language used by many artists in the eighties and nineties. Because the media was so influential in people's lives reality and the representation of reality on television and in movies, newspapers and magazines began to overlap. Because American life was so overwhelmed by the influences of the mass media, artists took the stance that art could no longer be made up of fresh ideas and images that are truly original. Art in the eighties and nineties became a translation and reexamination of images, and ideas, encountered and experienced in a lifetime of data, into works of art.

Many artists concentrated on how images and symbols changed or lost their meaning when put into different contexts. Julian Schnabel, probably the most successful young U.S. artist of the 1980s and 1990s, recycled all

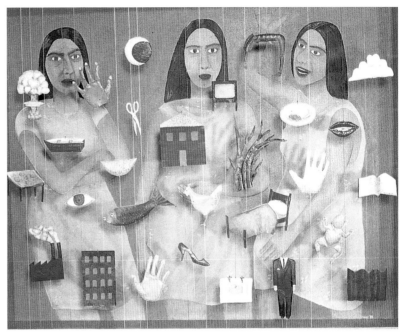

▲ *Marina Gutierrez's work is inspired by Puerto Rican folk art. She produced* Biography *in 1988 in acrylic on masonite, suspending body parts and shapes cut from painted metal in front of three self-portraits.*

Art Under Attack

Public funding for the arts, particularly through the National Endowment for the Arts (N.E.A.) created by the Johnson administration in 1965 and state arts-funding agencies, came under attack from right-wing political figures such as Senator Jesse Helms of North Carolina and from religious groups in the 1980s. They objected to tax-supported exhibitions, such as the one proposed and cancelled in July 1989 at the Corcoran Gallery in Washington, D.C., of photos by Robert Mapplethorpe. Mapplethorpe's photos of homosexuals created great controversy, resulting in Cincinnati's Contemporary Arts Center and its director being taken to court on obscenity charges for showing the pictures. The N.E.A. was put under great pressure by Congress, organizations like the American Family Association and religious groups, who tried to shut down the N.E.A. When that did not succeed, they tried to restrict its grant-giving powers. ■

Are you going to let politics kill Art?

Art should be supported by government and protected from politics.
Until now that has been the enlightened principle that has guided all legislation affecting the Arts in America. Art must live free to survive.
That is why it is crucial that every friend of the Arts send a message to Washington right now.
There is still time for cool heads and common sense to prevail over the Helms amendment to the appropriations bill for the National Endowment for the Arts.
But the Arts desperately need your help now. Today.
It is with a sense of the greatest urgency that we ask you to write to the people in Congress who will be meeting in the next few days in a crucial conference between the Appropriations Subcommittees of both Houses to resolve differences in the National Endowment for the Arts legislation.
The names and addresses of the Congressional people to contact are listed below.
You are probably aware of the controversy that inspired the devastating amendment by Senator Jesse Helms. In a July 28 editorial, entitled "The Helms Process," the New York Times wisely urged Congress to protect the legislation that insulates art from politics. It observed:

"The Helms process would drain art of creativity, controversy – of life... and would plunge one esthetic question after another into the boiling bath of politics. That's unlikely to be good for politics; it would surely be fatal to Art."

Don't let moral panic and political pressure kill the Arts.
Don't assume that "someone else" will fight this battle for you.
Write, call, fax, or telegram the Congressional leaders listed below *now* and urge them to delete the Helms provisions from the conference report on H.R. 2788.

Trustees of the Whitney Museum of American Art

WHO TO CONTACT:

SENATE SUBCOMMITTEE ON THE INTERIOR TELEPHONE 202-224-7233 Address for Senators: U.S. Senate, Washington, D.C. 20510			HOUSE SUBCOMMITTEE ON THE INTERIOR TELEPHONE 202-225-3081 Address for Representatives: House of Representatives, Washington, D.C. 20515		
	Telephone	FAX		Telephone	FAX
Sen. Robert Byrd (D-WV) Chair	202-224-3954	202-224-8070	Rep. Sidney Yates (D-IL) Chair	202-225-2111	202-225-3493
Sen. Dale Bumpers (D-AR)	202-224-4843	NONE	Rep. Chester G. Atkins (D-MA)	202-225-3411	NONE
Sen. Quentin Burdick (D-ND)	202-224-2551	202-224-1143	Rep. Les AuCoin (D-OR)	202-225-0855	202-225-2707
Sen. Dennis DeConcini (D-AZ)	202-224-4521	202-224-8698	Rep. Tom Bevill (D-AL)	202-225-4876	202-225-0842
Sen. Ernest Hollings (D-SC)	202-224-6121	202-224-3573	Rep. Norman D Dicks (D-WA)	202-225-5916	202-225-1176
Sen. J Bennett Johnston (D-LA)	202-224-5824	202-224-2501	Rep. John P Murtha (D-PA)	202-225-2065	202-225-5709
Sen. Patrick Leahy (D-VT)	202-224-4242	202-224-4797	Rep. Bill Lowery (R-CA)	202-225-3201	202-225-7383
Sen. Harry Reid (D-NV)	202-224-3542	202-224-7327	Rep. Joseph M McDade (R-PA)	202-225-3731	202-225-9594
Sen. Thad Cochran (R-MS)	202-224-5054	NONE	Rep. Ralph Regula (R-OH)	202-225-3876	202-225-3059
Sen. Pete Domenici (R-NM)	202-224-6621	202-224-7371			
Sen. Jake Garn (R-UT)	202-224-5444	NONE			
Sen. James McClure (R-ID)	202-224-2752	202-224-1006			
Sen. Don Nickles (R-OK)	202-224-5754	NONE			
Sen. Warren Rudman (R-NH)	202-224-3324	NONE			
Sen. Ted Stevens (R-AK)	202-224-3004	NONE			

◄ This full-page open letter was published in the September 7, 1989, issue of The New York Times *to oppose the amendment Senator Helms proposed to the appropriations bill for The National Endowment for the Arts. The Helms Amendment was not approved, but it created much concern.*

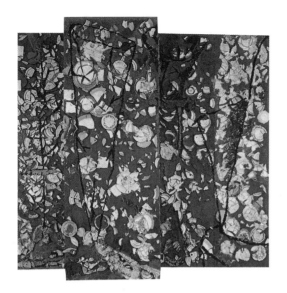

▲ *It is not clear what Julian Schnabel's (1951–) 1978 work entitled* The Patients and the Doctors *is about. He often uses objects from real life, in this case broken dishes, in his works of art. He says his intention is to captivate the public with his paintings.*

sorts of media images and combined them with real-life objects and materials. Schnabel took on religious, medical and art historical issues in his art, but like much art of this period, the viewer is left uncertain about what a work by Schnabel actually means. Just like life in the eighties and nineties, some of the art, too, offered no answers or real meaning.

The changing meaning of images in art and life was not the only

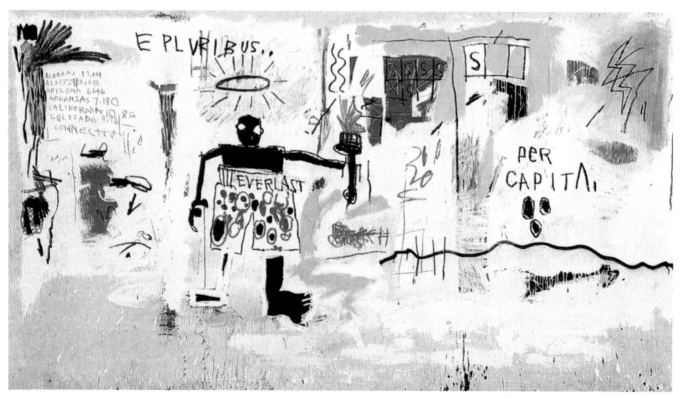

▲ *Jean-Michel Basquiat's (1960–86)* Per Capita, *produced in 1982, is a collage in acrylic and oil stick on canvas. In many of Basquiat's paintings, a black person is the main character. Basquiat said of his work: "I realized I didn't see many paintings with Black people in them." He said that his paintings are ". . . about eighty percent anger."*

▲ *Judy Chicago's 1979 piece* The Dinner Party, *is a multimedia installation. Chicago intended to document a little bit of the history of women in this work.*

Demand for Change

The American women's rights movement, born in the early 1900s, picked up steam in the 1960s. It continued to attract strong support in the late 1980s and early 1990s as issues such as women's rights, abortion and sexual harassment in the workplace became of greater concern to Americans than the issues of drug abuse, homelessness, affordable health care and racial inequality. Because the women's movement was strong, persistent and saw results, it provided a model for other groups—blacks, Latinos, Chicanos, Asians and gays, among others—who had become demoralized by the twelve years of what they saw as hostility to and neglect of issues important to them in the Reagan and Bush administrations. In part because many Americans wanted things to change, Bill Clinton (1946–) was elected president in 1992. Clinton's combination of knowledge about issues, excellent communication abilities and an empathy for the daily struggles of Americans helped him to win forty-four percent of the popular vote. ■

▲ *The Canadian artist, Bruce Barber (1950–) produced* Nam II *in 1990. It is based on the Pulitzer prize-winning photo taken by Eddie Adams in 1968. Barber has said, "I am interested in the notion. . . that one or two significant images could be said to summarize a whole war."*

theme pursued by artists in the eighties and nineties. Postmodern artists, as they have come to be called, also seemed to be in search of their own identities in the work they produced. Artists explored in their art their sexual identities, race, class, ethnic backgrounds and roles of their gender in relation to the environment, other people, their religion, their country, its government and its politics. For hundreds of years, in most western cultures, art had been produced predominantly by and for white, upper-class, heterosexual, western men. While they always coexisted with women, people of color and other minorities—members of society excluded, or not allowed to participate in the art world or other aspects of modern life—these men received all the economic and educational privileges society could offer. Other groups generally were not offered these things. This all now began to be questioned and challenged in the eighties and nineties in art and in real life. Issues of gender and sexual identity and the goal of achieving a more equal, multi-cultural society, became themes of much of the art made in the eighties and nineties.

Postmodern artists attacked the mass media, figures of authority, and the ideology that sets up inequity in society. Activism through their art and questioning the establishment were important activities for Postmodern artists. These artists once again challenged what art had become and the context in which all art must inevitably be viewed—that of the larger world—just as artists did at the turn of the twentieth century.

Bibliography

Antin, David et al. *Video Art*. Philadelphia: Institute of Contemporary Art, University of Pennsylvania: 1975.

Armstrong, T. and Lipman, J. *American Folk Painters of Three Centuries*. New York: Arch Cape Press, 1988.

Battcock, Gregory (ed.). *Minimal Art: A Critical Anthology*. Berkeley and London: University of California Press, 1995.

Bolton, Richard. *Culture Wars: Documents from the Recent Controversies in the Arts*. New York: The New Press, 1992.

Goetzmann, William H. and William N. *The West of the Imagination*. New York and London: W. W. Norton and Company, 1986.

Gordon, Lois and Alan. *The Chronicles of American Life 1910–1992*. New York: Columbia University Press, 1995.

Green, Martin. New York 1913, *The Armory Show and the Patterson Strike Pageant*. New York: Macmillan Publishing, 1988.

Hunter, Sam. *American Art of the 20th Century*. New York: Harry N. Abrams, Inc., 1972.

Lippard, Lucy R. *Pop Art*. New York and London: Thames and Hudson, Ltd., 1994.

Mellen, Peter. *Landmarks of Canadian Art*. Toronto: McClelland and Stewart, 1978.

Rose, Barbara. *American Art Since 1900: A Critical History*. New York: Frederick A. Praeger, 1968.

Stangos, Nikos (ed.). *Concepts of Modern Art from Fauvism to Post Modernism*. New York and London: Thames and Hudson, Ltd., 1994.

Tashjian, Dickran. *A Boatload of Madmen: Surrealism and the American Avant-Garde 1920–1950*. New York and London: Thames and Hudson, Ltd., 1995.

Tomkins, Calvin. *Off the Wall: Robert Rauschenberg and the Art World of Our Time*. New York: Penguin Books Ltd., 1980.

Acknowledgements

The author wishes to thank John Turner and James Warren for help with the book and the series.

Glossary

assemblages Works of art made from fragments of discarded everyday objects.

automatic drawing, painting and writing A method of drawing, painting or writing in which the artist allows his subconscious mind to control the movements of the hand.

avant-garde art Art that was experimental and pioneering.

Benday dots The small dots that together form an image in offset printing.

collage A work of art that combines photographs or other printed images with painted and/or drawn area.

combine A work of art that combines everyday objects, sometimes discarded material, with painted and/or drawn areas. Robert Rauschenberg invented the word to describe the work he began to do in 1955.

Cubism An important movement in painting and sculpture in which the object or scene was represented as if the viewer could see it from many perspective in a single painting, collage or sculpture. Pablo Picasso and Georges Braque were the leading artists who worked in this style mainly between approx. 1907 to 1914. This movement is considered one of the turning points in western art.

Dadaism An anti-art movement that rose up after World War I in Europe in which illogical and absurd ideas were important to artistic creation. The artists depended on elements of chance in their work and attempted to shock their audience. The "readymade" was the main form Dada art works took, in which a mass-produced object, such as a piece of furniture or bicycle part, was chosen and displayed as a work of art.

Fauvism A style of painting that used bright, unnatural colors. Henri Matisse was the leading painter in this style that reached its peak about 1905-06 in France.

Futurism A political art movement that hoped to free Italy from the old-fashioned ways of its past. Its influence spread to Russia and other parts of the world.

hard-edged style Paintings in which the forms are painted in flat areas of color with sharp edges.

monochromatic Works of art produced in one color.

mural A painting or collage produced directly on a wall or actually affixed to the wall.

naive style Works of art produced in civilized societies by artists that do not use conventional methods of representation such as perspective.

painterly A way of painting in which the artist represents a form through color and not by outlining or drawing it.

rotogravure A printing process used to print, among other things, newspaper images. The society pages of newpapers became known as the "rotogravure" because of the use of so many pictures.

silkscreen A color printing process in which a stencil created on a fine screen of silk, attached to a wooden frame, is printed by forcing color through the screen onto the surface to be printed.

Surrealism A 1920s and 1930s art movement that started in France and focused on strange and irrational elements in its expression. It grew from the Dada movement. Automatic painting. drawing and writing were some of the activities of the movement's followers who attempted to explore the activities of the unconscious mind. It spread through Europe and finally to the Americas.

trompe-l'oeil A French word which means "trick the eye", it is used to describe paintings that attempt to mislead the viewer into thinking the paintings are the real objects they represent.

Photo Credits

The Albright-Knox Art Gallery: 33 right

Amalgamated Clothing and Textile Workers Union: 20 right

Amon Carter Museum of Western Art, Fort Worth, Texas: 16

The Art Institute of Chicago: 24 top, 35 right

The Baltimore Museum of Art: 39 bottom

courtesy Leo Castelli Gallery, New York: 44 top

Copyright © 1953, estate of Giorgio Cavallon: 32

The Cleveland Museum of Art: 26 bottom

The Congressional Library, Washington: 49 top

Courtesy Dwan Gallery, New York: 51 bottom

Thomas Gilcrease Institute of American History and Art, Tulsa, Oklahoma: 11 right

Estate of Keith Haring: 56 right

Photo courtesy of The Jewish Museum, New York: 48 bottom

The Library of Congress: 15 bottom left

Copyright © Herbert Matter: 34 right

McMichael Canadian Collection: 27 right

Courtesy Robert Miller Gallery, New York: 58 bottom

The Museum of Modern Art, New York: 19 center, 22 left

Museum of the City of New York: 13 bottom left, 20 bottom right, 29 bottom left

Copyright © Hans Namuth: 34 left

Copyright © NASA: 55 top

National Anthropological Archives, Smithsonian Institution: 11 bottom left

National Archives: 10, 13 right, 19 bottom, 24 bottom, 25 top, 26 top, 29 right, 36 top left, 49 bottom

National Gallery of Art, Washington: 14 right, 19 top, 47 bottom left

National Museum of the American Indian, Smithsonian Institution: 11 top left

National Portrait Gallery, Washington: 14 left, 15 top right and bottom, 20 bottom left

The New School for Social Research, New York City: 27 bottom left

Courtesy The Pace Gallery, New York: 40 bottom

Copyright © Bucky Parzych: 28 bottom right

Photo copyright © Cynthia Parzych Publishing, Inc., collection of Jim McCleery: 31 left

Philadelphia Museum of Art: 20 top, 23 bottom

Private Collection: cover, 12 left and right, 13 top left, 15 top left, 17 top and bottom left and top right, 18, 20 top, 23 top, 25 bottom, 35 left, 36 right, 40 top, 41 top left and right, 42 right and left, 43 top and bottom right and left, 44 bottom, 45 top, 46 left, 47 center and right, 48 top, 50 top and bottom, 51 top and center, 52 top and bottom, 54 right and left, 55 bottom, 56 left, 57 top, 58 top, 59 top and bottom

Drawing copyright © 1937, 1975 Carl Rose, courtesy *The New Yorker Magazine, Inc.*: 33 left

The Tate Gallery, London: 41 bottom left

Collection of Mr. and Mrs. John A. A. Turner: 30 top and bottom, 31 right

U.S. Information Service: 39 top

Walker Art Center, Minneapolis: 47 top right

Whitney Museum of American Art, New York City: 27 top left, 28 top, 29 top, 38 top and bottom, 46 right

Courtesy John Weber Gallery: 53 top

Courtesy Nicolas Wilder Gallery, Los Angeles: 45 bottom

Yale University Art Gallery: 22 top right

Index

INDEX